True Nature

An Illustrated Journal
of Four Seasons in Solitude

BARBARA BASH

KTD Publications · Woodstock, New York

To the memory of
my mother
Flora Oberg Bash

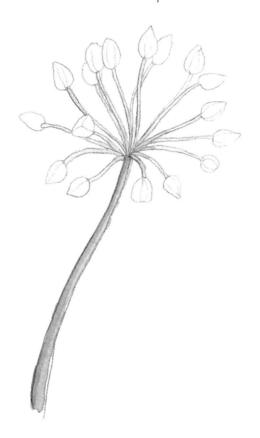

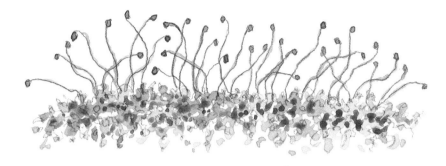

CONTENTS

Heading up...

Introduction

This is the story of four solitary retreats spent in a cabin in the Catskill mountains of upstate New York. During these times I practiced sitting meditation and nature journaling. Both activities are contemplative, developing awareness and attentiveness to the world. I wanted to see how they might weave together when mixed with the simplicity and starkness of solitude.

Each season of retreat had its particular quality— the active aliveness of summer; the abundance and poignancy of autumn; the bare-bones, pulled-in depth of winter; the pushing-through emergence of spring. At the same time, crucial inner themes appeared again and again: uncertainty and self-doubt, a lost feeling and the relief of finding my way, a sadness that enveloped me, a fear of the dark, and a gentle-ness and ease with myself and the world.

When I began the retreats, I had been prac-ticing and studying Tibetan Buddhism for a number of years. The tradition of retreat is well established in Buddhism. Meditating alone in simple and usually remote settings is seen as a powerful way to experience the nature of one's mind.

stepping away from the human world sheds one's cover. In retreat, there is no surrounding and habitual social interaction. This can be a big relief. It can also feel naked, exposing, and enormously lonely.

I began practicing Buddhist meditation in the 1970s. Following the advice of my teacher, Chögyam Trungpa, I scheduled a ten-day retreat in a cabin nestled deep in the southern Colorado mountains. The loneliness that confronted me on that retreat was a shock. All my demons of doubt and fear raced in to attack. Every day the setting sun and approaching darkness filled me with panic. Being alone had peeled away some layer of safety. A deep and instinctive sense of danger emerged. I was apart from the tribe and unable to see what lurked in the shadows. One night, I made myself step outside onto the porch. I looked up into the dark sky, my heart pounding, gripping the door handle behind me. I took a few deep breaths of the cool night air but I never let go of that door handle. After nine days of struggling with my fears I decided to go home a day early. This was the only moment on the whole retreat that I felt some kindness toward myself. The rawness of this experience haunted me for a long time afterward.

Many threads of contemplative practice have woven through my life in the years since.

My study of calligraphy led me to an ancient Chinese grounding brush practice — the making of a straight line. It was taught to me by Ed Young, who studied with Professor Cheng Man'ching. Beginning with clear water, the brush is pulled across the page, following the turning of the body. The stroke dries and vanishes. Gradually drops of ink are added to the water, building to a full-strength blackness. Repeating the gesture over and over, the body steadies, the mind settles, and the lines become fuller and stronger, saturated with attention. I practiced making these lines for hours and days and weeks at a time, comparing the ideal of my intention with the reality of each line. If "calligraphy is a picture of the mind," as the Zen saying goes, I was deeply attracted to taking a look with brush and ink.

I began to work with larger brushes and bigger, spontaneous strokes. I made my own big brush out of three-foot lengths of horsehair. I dipped it in gallons of sumi ink and pulled it across yards and yards of paper. Huge marks emerged in the moment. Because of the enormous scale, my whole body became part of the movement and my mind had no time to control or strategize the results. Working with this brush required full attention and a willingness to leap into the unknown. I found the experience exhilarating.

My work with calligraphy and design evolved into writing and illustrating books on natural history for children. I traveled to experience my subjects firsthand — to Africa to see the baobab tree, to India and Indonesia to sit under the banyans, to the Pacific Northwest to experience the old-growth forest. I observed the network of relationships — insects, birds, mammals, reptiles, and humans — that were nourished and protected by the trees. Recording this aliveness became a practice in itself, a way of contemplating the natural world by sitting still and watching. My pencil on the page followed the movements. I wrote down first thoughts, simple and direct. The sketchbooks I filled on these travels held a freshness and vitality that I trusted.

I returned to retreat sixteen years later. I was married, with a young son and a full life of creative work and relationships. This time I wanted to combine the basic groundlessness of meditation with the inquisitiveness of nature journaling. That deep fear of being alone in the dark was still there. The longing to relax with the fear was also there. Going on retreat felt like walking out of a warmly lit home into the dark still night: not exactly comfortable, yet powerfully right.

I found a small cabin on private land two hours north of my home. It had a spacious layout: a simple kitchen with a wood-burning stove and dining table, a room for meditation, and an upstairs bedroom. There was running water and a small shower and toilet. The cabin sat on top of a high hill surrounded by meadows and woods and faraway farms. There was land to explore. In the four seasons of my retreats, I hiked down the wide meadows and scrambled up rocky out-croppings. I was caught out in downpours and once lost my way in a snowstorm. I came to know the land well and returned to certain spots each season. Sometimes I felt like a trespasser on pristine ground, a disturber of the peace. But the settling quality of sitting meditation gradually softened my awkwardness. I sat with the feeling of being a disturbance. I sat with the loneliness and fear. I sat until I became part of the rhythm of the place.

This is a record of that ancient process of coming to rest where we are. It is a journal that traces the experience of being both alone and connected to the world. It is a story of stepping outside that safe, warm home and discovering the vast night sky.

RUMI

The breeze at dawn has secrets to tell you.
Don't go back to sleep.
You must ask for what you really want.
Don't go back to sleep.
People are going back and forth across the doorsill
where the two worlds touch.
The door is round and open.
Don't go back to sleep.

Late by myself, in the boat of myself,
no light and no land anywhere,
cloudcover thick. I try to stay
just above the surface, yet I'm already under
and living within the ocean.

Do you think I know what I'm doing?
That for one breath or half-breath I belong to myself?
As much as the pen knows what it's writing,
or the ball can guess where it's going next.

For years, copying other people, I tried to know myself.
From within, I couldn't decide what to do.
Unable to see, I heard my name being called.
Then I walked outside.

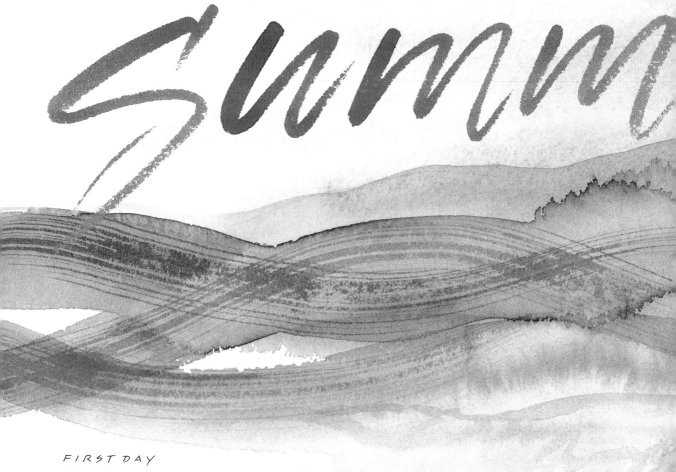

Summe...

FIRST DAY

On a bright morning in early July
I drive two hours north of my home
and pull up at the cabin. It sits on the
edge of a high meadow surrounded by
rolling hills dotted with farms.
I bring in food, clothes, and bedding.
Then I sleep for three hours in the
middle of the afternoon — the hot,
quiet time of day.

Later, when the sun begins to drop
and the air cools, I sit in the dappled
light in front of the cabin listening
to a woodpecker's drumming far away.

I will be here for a week by myself,
sitting in meditation, taking walks,
drawing, writing.

I am heading back into the solitude
that was so disturbing sixteen
years ago. I feel shaky and unsure
of my footing all over again.

In the early evening a pair of
woodchucks forage in the big
meadow below the cabin. As the
sun goes down, I sit out on the hill-
side and watch them through
binoculars. They stay close to the
ground, their wide bodies flattening
as they lumber along. Then
suddenly they're sitting up straight,
scanning the horizon.
They take no notice of me.

16

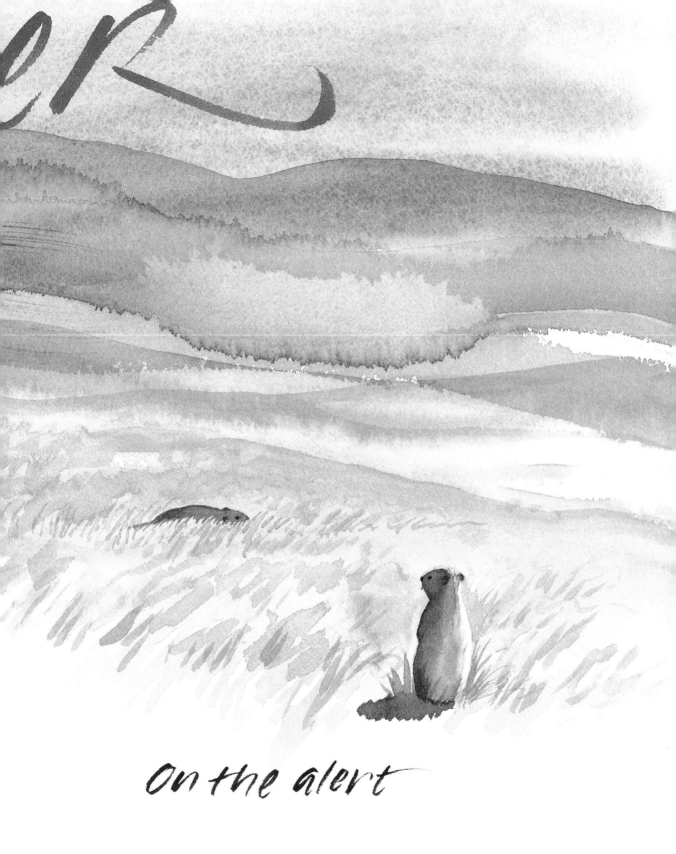

on the alert

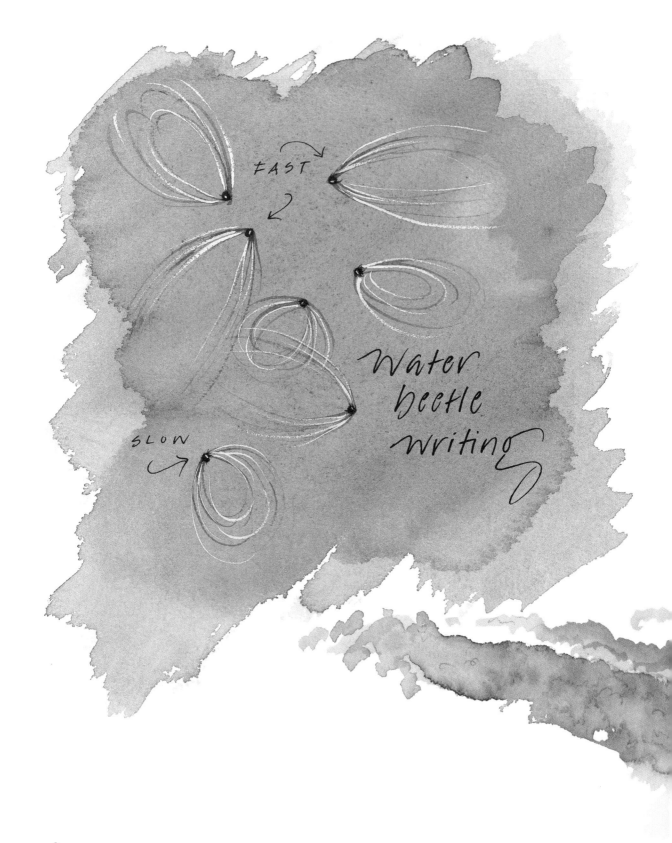

FAST

Water
beetle
writing

SLOW

After dinner I set up the shrine on a low table: two candles, a tea-offering cup, a small dish for burning incense, seven bowls filled with clear water, and a picture of my Buddhist meditation teacher, Chögyam Trungpa, making a big black brushstroke on a large sheet of paper. When I was packing to come up here I chose that picture over more formal portraits because it showed his artist's mind. I remember him saying once, "It is possible to make a brushstroke that expresses one's whole life."

I sit for an hour in front of this shrine, legs crossed, hands resting on knees, eyes open, following the outbreath. I sit watching my mind — restless, jumpy, shifting. I remember to follow my breath only once or twice during the hour. It's going to take some time to settle down.

SECOND DAY

I wake early and sit in meditation, settling into my body, watching my mind move. Then I make breakfast and head out for a walk through the woods and down the hillside, coming upon a large secluded pond. As I approach, the frogs begin a chorus of deep thrumming. Are they announcing my arrival? I sit at the edge and watch water beetles skating on the surface and small newts drifting up and down in the shadows. Then I discover I am being closely watched by a big green frog. I slowly pull out my sketchbook.

Deeply resting, more and more sleeping. Exhaustion is pulling me down. My insides are heavy. There are voices tisking and shuddering at such laziness, but I am listening to deeper voices.
Sleep. Dream. Wander.

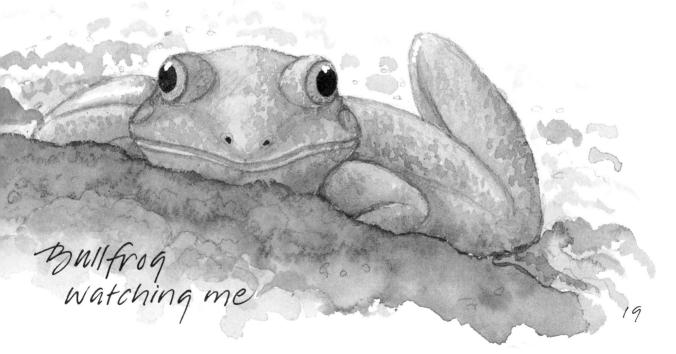

Bullfrog
watching me

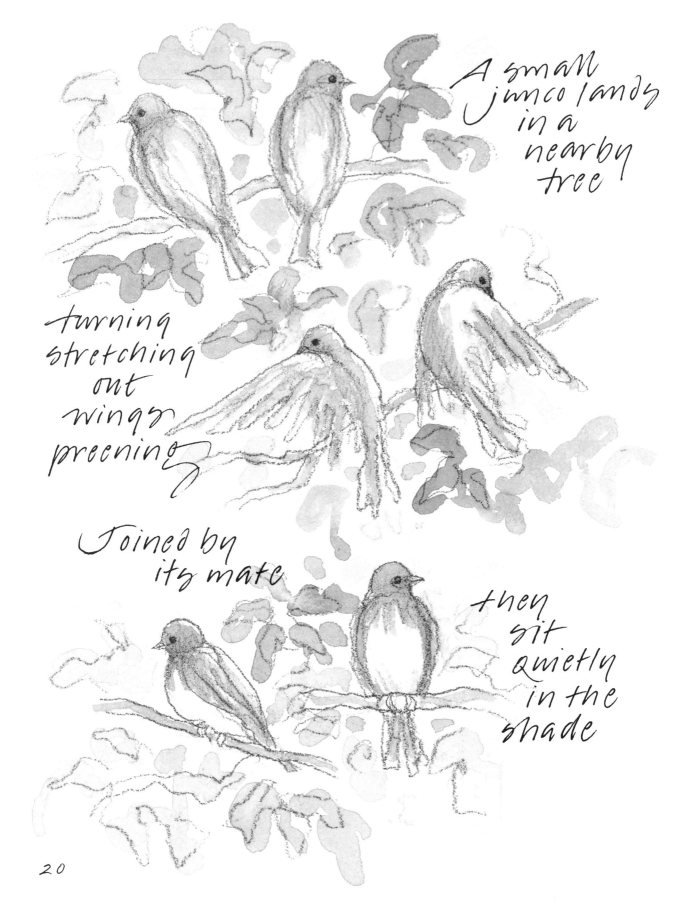

A small
junco lands
in a
nearby
tree

turning
stretching
out
wings
preening

Joined by
its mate

then
sit
quietly
in the
shade

20

I am sitting and gazing out at the landscape. There is nothing to accomplish. Not true! I'm supposed to be out walking and drawing and gathering insights and...
Can I let the push to be doing something drop away? In THE WISDOM OF NO ESCAPE, Pema Chödrön says, "Exercise your willingness to rest in the uncertainty of the present moment over and over again."

I realize that I am alone here. It is a little shock, bringing with it a weight, a nervousness, an anxiety, and then... not so bad, nothing bad happening here... and a sweetness sneaks in.

Saw a small snake today slithering out of sight along the gravel road at the bottom of the hill. I'd like to find one to sketch. I am calling to a snake, "Please let me see you."

When I return to the cabin at twilight a brown snake is sipping rainwater off the front step.

THIRD DAY
In the morning I step out on the porch and see another smaller brown snake sliding away across the step, disappearing between the rocks and under the cabin. Now I'm wondering if I'm living above a whole family.

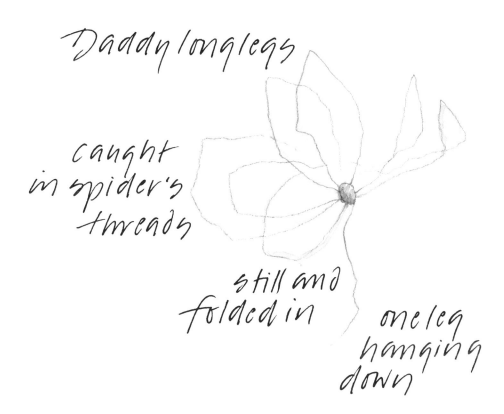

Daddy longlegs

caught
in spider's
threads

still and
folded in

one leg
hanging
down

LARGE POND

WHITE TAIL DRAGONFLY

watched water beetles

was watched by frogs

9

followed dry

NAPPED

BEAVER CUT STUMP

woke to a surprised deer

headed down steep hillside

crossed new logging road

8

7

FERNS GROWING IN UNDERSTORY LIGHT

W O O D S

B I G

4 through opening into woods

6

passed disturbed area with trees cut - lots of debris

5

climbed onto big rock outcropping

creek to
10

SMALL
POND
CHORUSING FROGS

steep hillside

crisscrossed up

thick brambley

CLOTHES SNAGGED
ON THORNS

11 through
shrubs &

R O A D

WOODCHUCK
HOLES

MORNING
WALK

B I G F I E L D

13 circled white stupa

where is
my hat?

12

ANCIENT
SYMBOL
OF BUDDHA'S
MIND

14
back
ready
for
lunch

3

walked grassy path

2 sat on big rock
in morning sun

X

1

past big
fountain grasses

DAISIES
BY THE FRONT
STEP

left
cabin
after breakfast

Great broad leaves of burdock
late afternoon breeze
blows and rustles them

Being here by myself feels like
a pause, a break in a pattern.
The habitual knitting together
of schedules and demands is
beginning to unravel, the tight
secure knots of my life loosening,
relaxing. And then that raw
aloneness rushes in, and with it
the impulse to turn away,
run back home.

Staying put. Sitting still.
Letting thoughts move around.
This is a big space for mind
to wander... and settle.

the heat of
the land and
my mind cooling
down

drawing
these strong
shapes

25

I eat my lunch sitting on a chair on the front step in the sunshine. Out of the corner of my eye I sense a small movement and then see something glistening— a snake's glossy eye peering at me just over the edge of the big stone slab I am sitting on. My heart beats faster, but I hold very still, watching it as it watches me.

I am fascinated and trembling. The lord of the underworld has arrived and is speaking to me in his silent language. I am not frightened, only held in the spell of the moment.

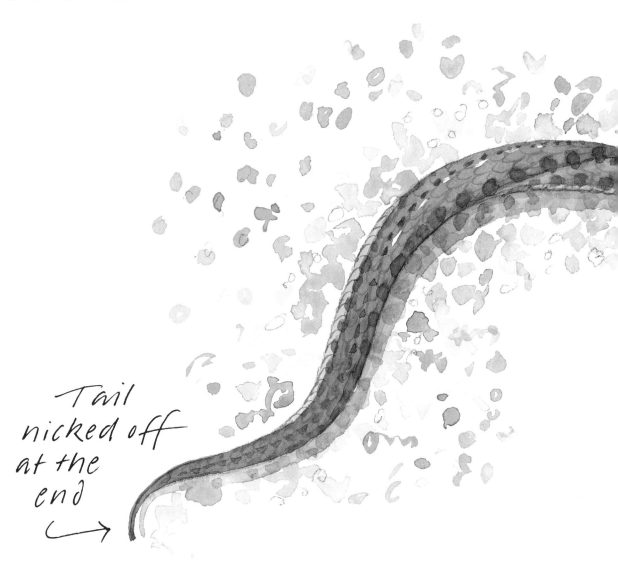

Tail nicked off at the end ⟶

26

B R O W N
S N A K E

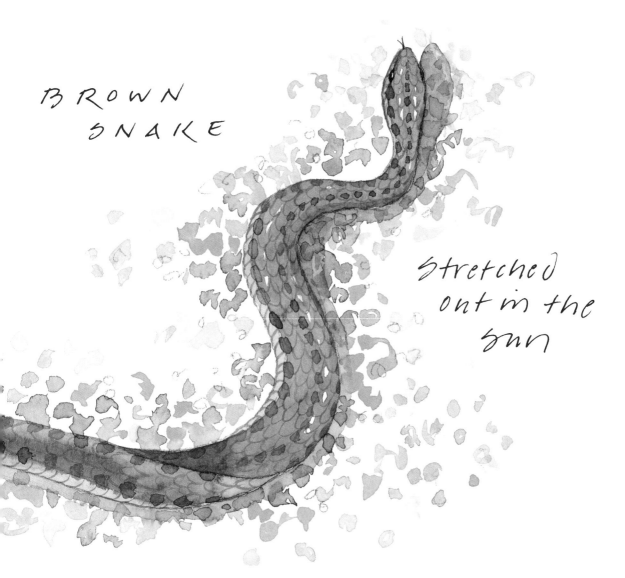

Stretched
out in the
sun

I hear another rustle and slowly turn my head to the right. Now there is a second smaller snake face watching me from the opposite edge of the stone slab. I sit now, surrounded and completely alert, turning my head slowly side to side, observing and being observed.

After ten minutes, both snakes slip down into their dark cracks and then the larger one reappears on my right, head swaying, black tongue flicking the air. It settles its length in full view along the sunny rocks at the edge of the wall and I sketch its long brown pattern. Just as I finish my drawing, it slides slowly away into the long cool grass.

Is there anything more beautiful than a snake moving through the grass?

27

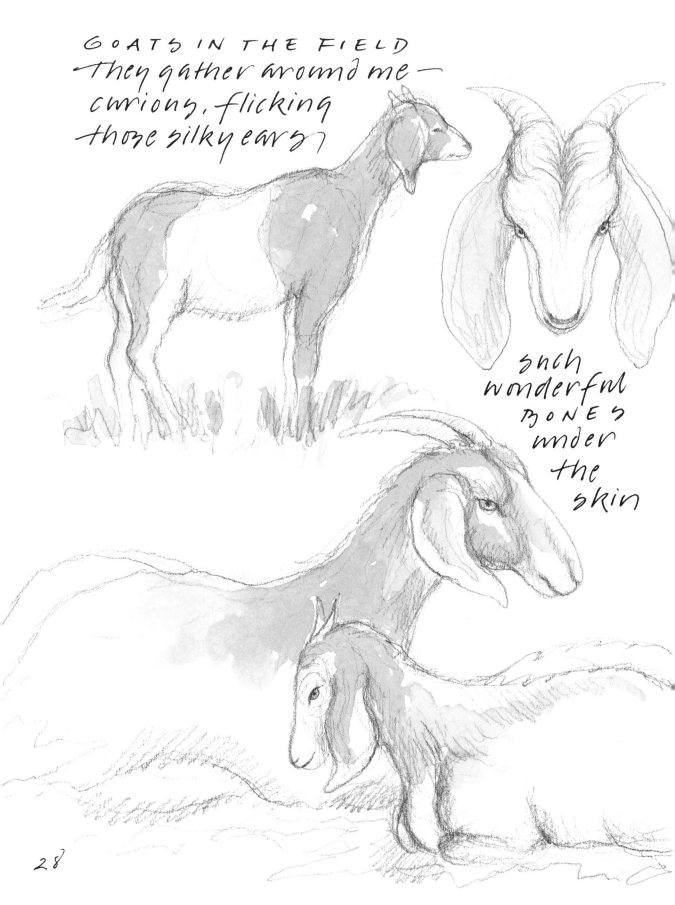

GOATS IN THE FIELD
They gather around me —
curious, flicking
those silky ears

such
wonderful
BONES
under
the
skin

28

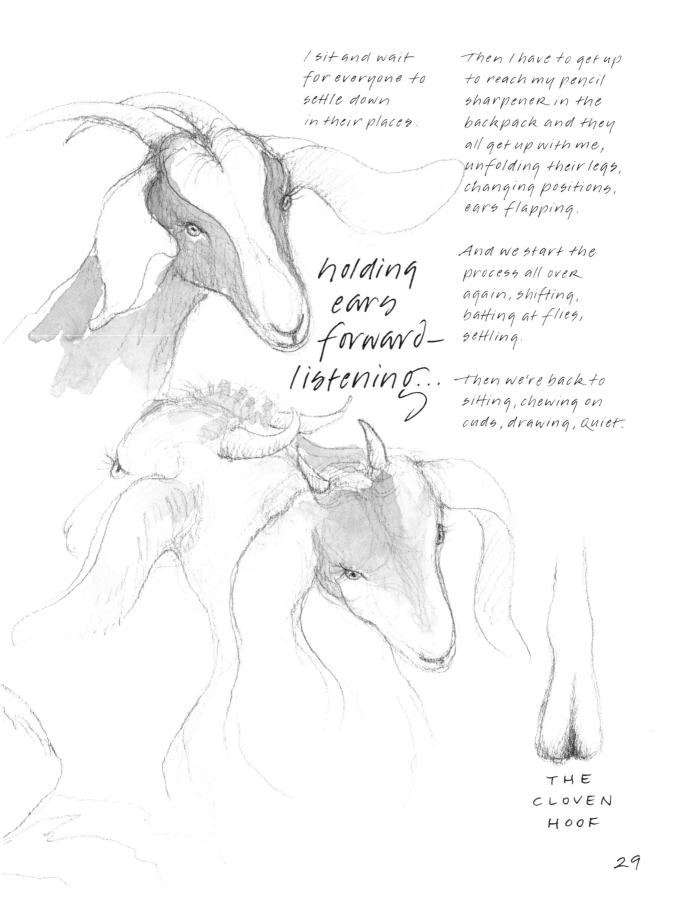

I sit and wait for everyone to settle down in their places.

Then I have to get up to reach my pencil sharpener in the backpack and they all get up with me, unfolding their legs, changing positions, ears flapping.

holding ears forward— listening...

And we start the process all over again, shifting, batting at flies, settling.

then we're back to sitting, chewing on cuds, drawing, Quiet.

THE CLOVEN HOOF

29

Bird calls in the afternoon

woodpecker

mourning dove

30

breeze rustling
leaves

airplane
passing
far over
head

cardinal

At dusk the birds become quiet,
settling into their roosts for the night.
I settle in too. But I find myself
thinking about the woods across the
meadow. I can't imagine walking into
that darkness. I touch my fear of the
dark woods at night. I tell myself
there is nothing to prove. I stay inside,
curled up on the bed, finding safety
in reading and writing and sleep.

FIFTH DAY
Last night was a noisy one: lots of
mouse activity in the cabin. It seemed
that each time I dropped off to sleep
I would wake with a start from the
sound of some chewing or scratching
of tiny paws, or some small metallic
object being knocked off a surface
and bouncing around. But I made it
through. The sun is pouring in the
window now. Birds are greeting
the light.

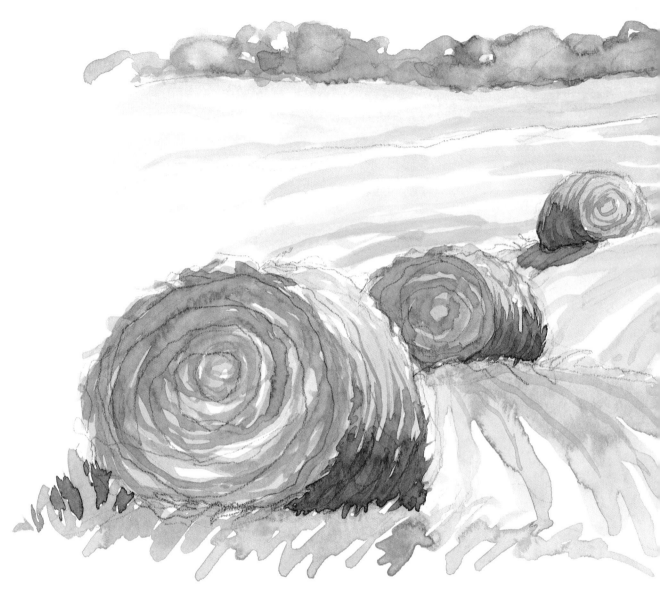

great sodden
rolls of hay

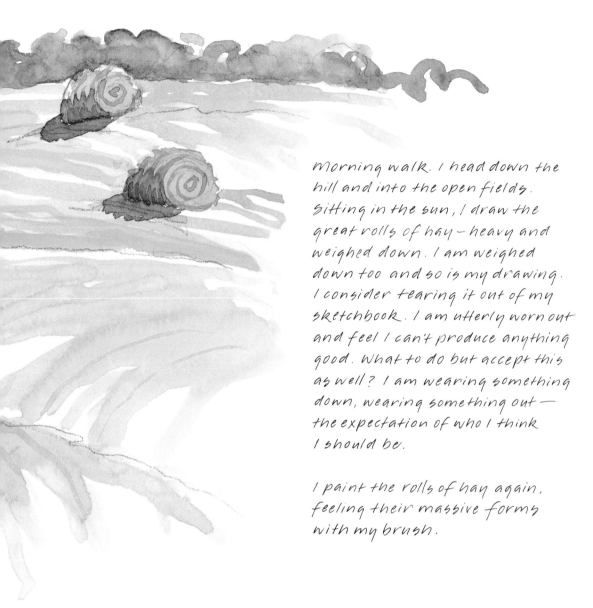

Morning walk. I head down the hill and into the open fields. Sitting in the sun, I draw the great rolls of hay — heavy and weighed down. I am weighed down too and so is my drawing. I consider tearing it out of my sketchbook. I am utterly worn out and feel I can't produce anything good. What to do but accept this as well? I am wearing something down, wearing something out — the expectation of who I think I should be.

I paint the rolls of hay again, feeling their massive forms with my brush.

"How do you react when you're not measuring up to your image of yourself? ... At these times it helps to remember that you're going through an emotional upheaval because your coziness has been, in some small or large way, addressed. It's as if the rug has been pulled out from under you."

Pema Chödrön, COMFORTABLE WITH UNCERTAINTY

Back in the cabin I am caught by sadness.
This is not where I want to be. I miss my
seven-year-old son, Wiley. I miss curling
up and reading to him, turning out the
light and holding his dear body until
his breathing deepens. I miss talking
to my husband, Steve, pouring out the
complaints and happiness of a day.
I miss my friends and all the social
contact, the warm friction with the world.
Up here the warmth comes from the
energy of my battling mind. I feel like
I'm in a boxing match with myself.
"Go draw. You'll feel better."
Yes but I don't want to move.
"You have no zest for life."
I know. I know. Let it drop, let it go,
let the world call me out. I'm so tired,
so worn out. "It's okay. It's okay."
The voices turn and turn around.
Each one neurotic, each one wise.

I watch a big fly frantically buzzing and
ramming into the windows and walls
of the cabin. It flew in through the open
window and now can't find its way out.
It is careening in every direction, noisy,
agitated. Yet after a few minutes it finds
the open window and sails out silently
into the big space.

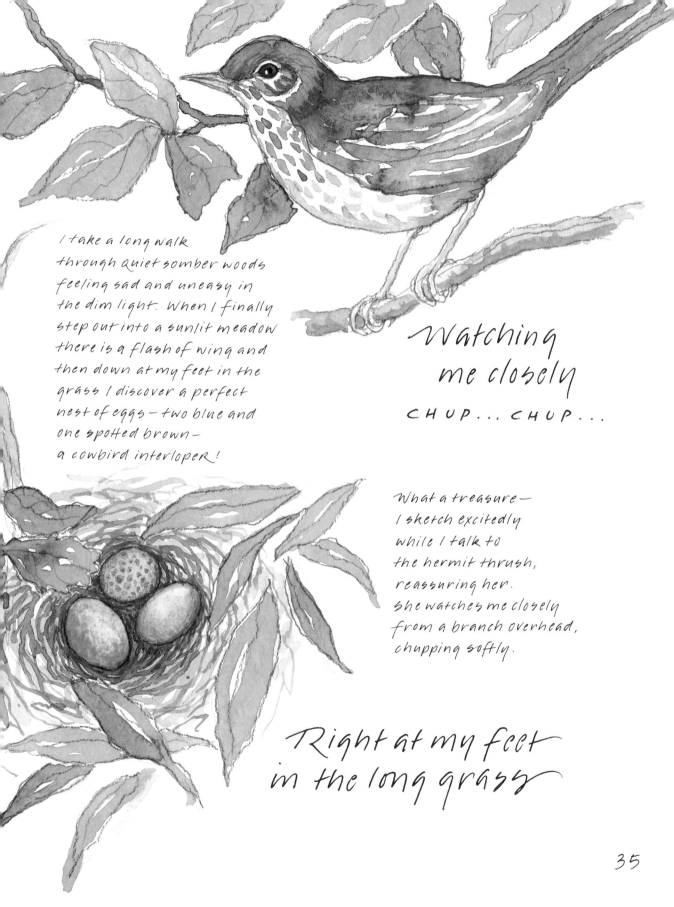

I take a long walk
through quiet somber woods
feeling sad and uneasy in
the dim light. When I finally
step out into a sunlit meadow
there is a flash of wing and
then down at my feet in the
grass I discover a perfect
nest of eggs — two blue and
one spotted brown —
a cowbird interloper!

Watching
me closely
CHUP... CHUP...

What a treasure —
I sketch excitedly
while I talk to
the hermit thrush,
reassuring her.
She watches me closely
from a branch overhead,
chupping softly.

Right at my feet
in the long grass

35

stretching between
 the porch and the closest tree—
a line of weathered prayer flags
 send their Tibetan blessings
 out on the wind

Walked out the door empty-handed
in the early evening (no sketchbook,
no backpack, no nothing) into the high
field nearby. Then I just kept going into the
next vast room of meadow, and the next, until
I came to a grand dome of mowed land, clear and
open, overlooking the winding road and farmhouse.
I walked all the way to the field's edge. Beyond was a big
unmown yard. As I approached, flocks of swallows and red-
winged blackbirds rose from the grasses, chirping and diving
and swooping like waves on the ocean. Two swallows joined me on the
dome and circled down, nearly touching the shorter grass, then lifted off
in wide arcs, crossing and soaring and dipping. I turned around and around
following their flight. The sky was pearly grey, like the inside of an enormous
shell. As I stood in the middle of this big wide space, the wind blew
all around and my thoughts blew in and out and all around
and I walked and looked and opened back up.

high broad hill—wide grey sky
swallows skimming the grass

bleached &
threadbare now
blowing in
cool evening
breeze

37

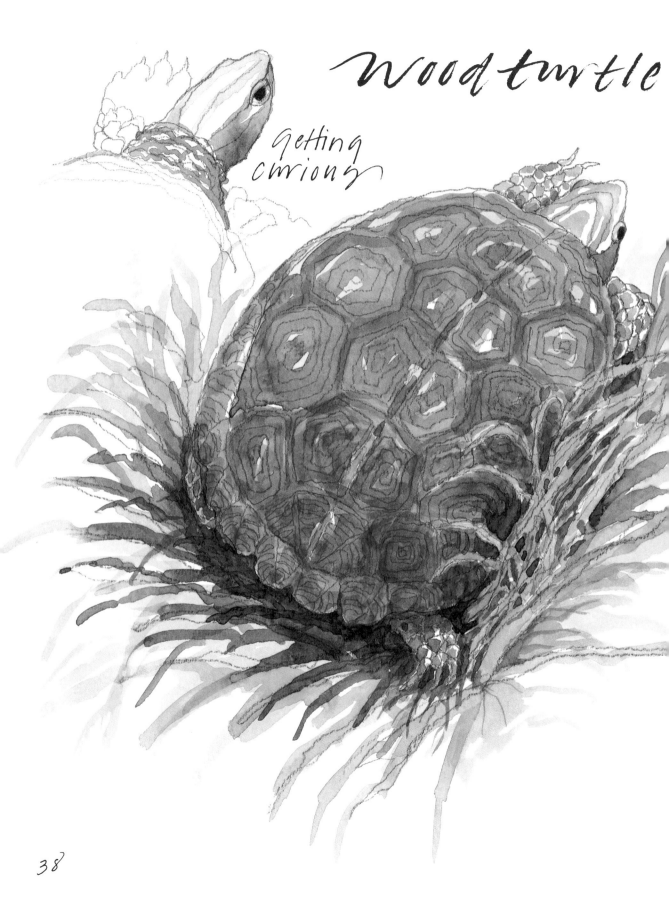

wood turtle

getting
curious

in the path

marching off

heading down the road

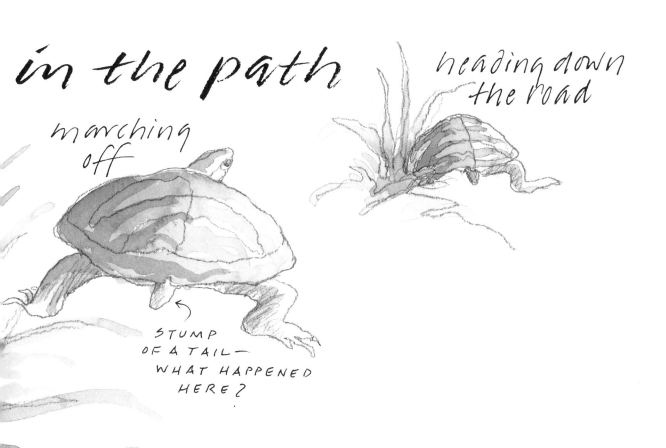

STUMP OF A TAIL— WHAT HAPPENED HERE?

SIXTH DAY

On my morning walk, in the middle of the grassy path, I come upon a big wood turtle, very still, head protruding slightly from its shell. As I sit down and start to draw I talk to him. I thank him for letting me stare, for being so patient, for not withdrawing. And as I talk, his black smooth head slowly, slowly stretches and turns toward me and I wonder if he is listening to the murmur of my voice or just waiting, waiting until my drawing is complete, the encounter complete, and it's time to go.

Just as I finish touching in some color on the page he marches off, big strong legs extending, his stump of a tail visible, crunching grasses on the path.

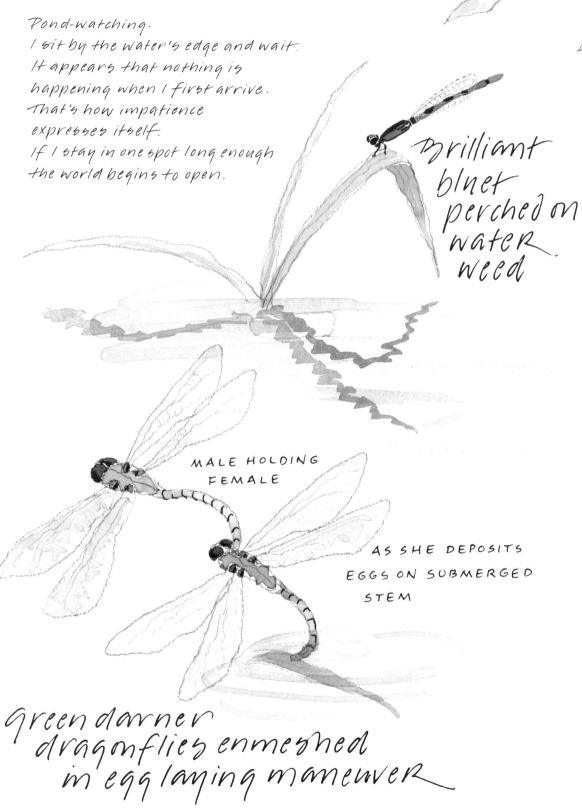

Pond-watching.
I sit by the water's edge and wait.
It appears that nothing is
happening when I first arrive.
That's how impatience
expresses itself.
If I stay in one spot long enough
the world begins to open.

Brilliant bluet perched on water weed

MALE HOLDING FEMALE

AS SHE DEPOSITS EGGS ON SUBMERGED STEM

Green darner dragonflies enmeshed in egg laying maneuver

40

Suddenly two
ducks take off across
the water

Water beetles
fighting over
a tiny dead fish

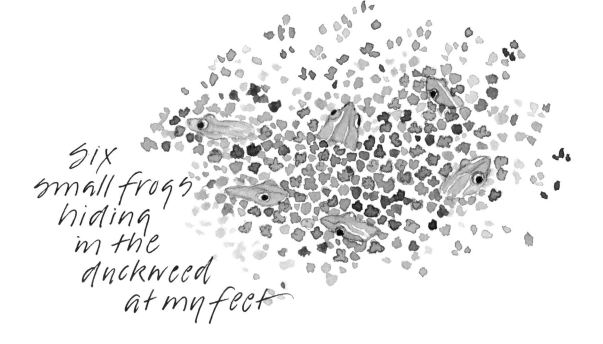

Six
small frogs
hiding
in the
duckweed
at my feet

Down at the other end of the pond I hear some splashing, but can't see what it is because of the big pile of sticks out in the middle of the water obstructing my view. I crouch low and begin to edge over for a closer look. Suddenly there is a big smack and splash, and swimming right past me comes a big beaver — only the head is visible — moving steadily back and forth. I am in full view yet he seems undisturbed by my presence. My heart is pounding hard. He turns and swims straight toward me, coming to within ten feet, then turns and paddles away.

After a thorough tour of my end of the pond, he abruptly dives under the water and disappears. I wait... and wait. Fifteen minutes later I see his head bobbing along beyond the den. Then he reappears out in open water, swimming evenly.
He passes me.
He raises his head a bit.

swims back

and right toward me!

then disappears

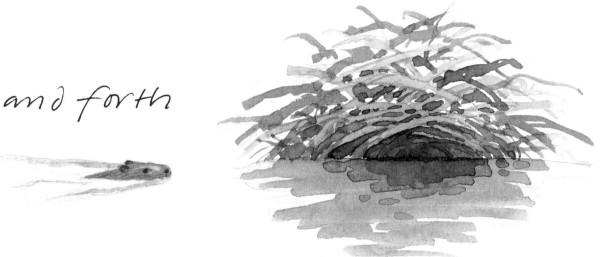

BEAVER'S DEN

and forth

I spot a scarlet tanager taking off from the trees across the way, flashing brilliant red. At the same instant, the beaver thwacks his tail on the water so hard I jump, my heart pounding all over again. He thwacks once more, then dives again into the dark depths. I retreat up the hillside to calm myself down.

THE FIELD GUIDE DESCRIBES BEAVERS AS SHY AND NOCTURNAL...

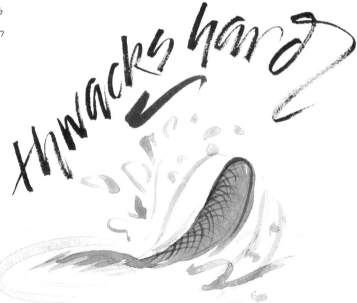

thwacks bang

AIR BUBBLE TRAIL

43

LAST DAY

The crows wake me up, cawing hoarsely across the field. It's breezy and cool when the sun goes behind a cloud. When it's shining through, I'm warm. After breakfast I sit in meditation out on the porch. My mind is still so jumpy after all this time. I can stay with the breath for about five seconds and then I'm off, staring at the grasses blowing, the stalks all nodding and bowing together. I remember a letter I wrote that hurt someone long ago. Wanting to ask forgiveness. Feeling sad, just feeling it, and then returning to breathing out and in... And then I'm gone again, who knows where. My knee is stiff, I change positions. Thinking about all the people I know who have died, I list them in my mind and see each life lived. For a moment I know the certainty of death. Reluctance to die. Reluctance to leave today. Ready to go — staying, going, thinking, breathing, easy, relax the stomach, relax the mind.

The wind blows around and my thoughts blow around and then, every so often, it all quiets down — here, this moment, here.

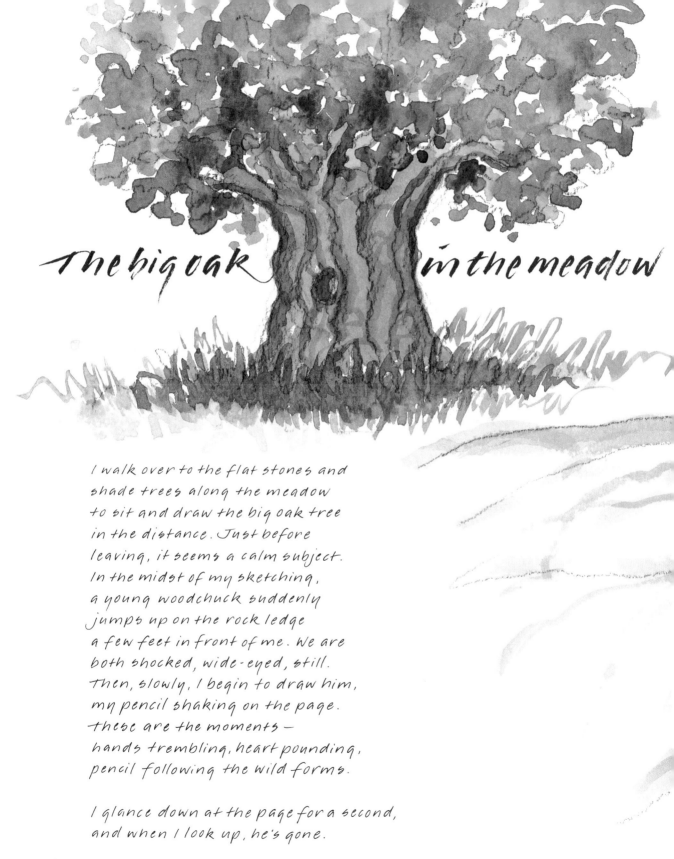

the big oak in the meadow

I walk over to the flat stones and
shade trees along the meadow
to sit and draw the big oak tree
in the distance. Just before
leaving, it seems a calm subject.
In the midst of my sketching,
a young woodchuck suddenly
jumps up on the rock ledge
a few feet in front of me. We are
both shocked, wide-eyed, still.
Then, slowly, I begin to draw him,
my pencil shaking on the page.
these are the moments —
hands trembling, heart pounding,
pencil following the wild forms.

I glance down at the page for a second,
and when I look up, he's gone.

46

YOUNG WOODCHUCK
popped right up
in front of me

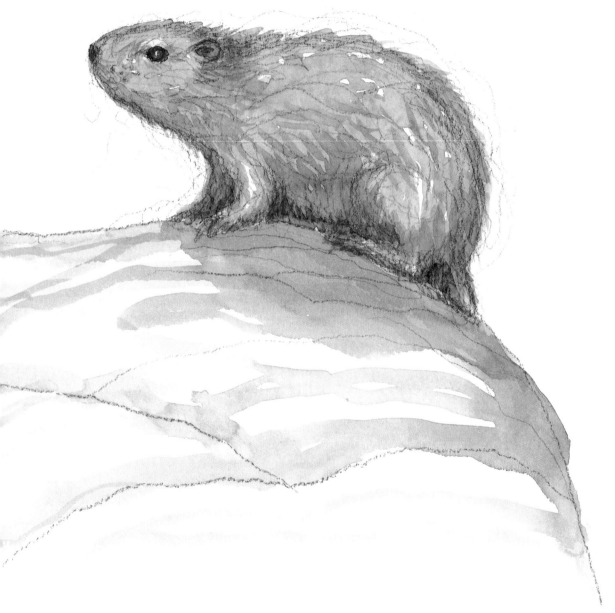

47

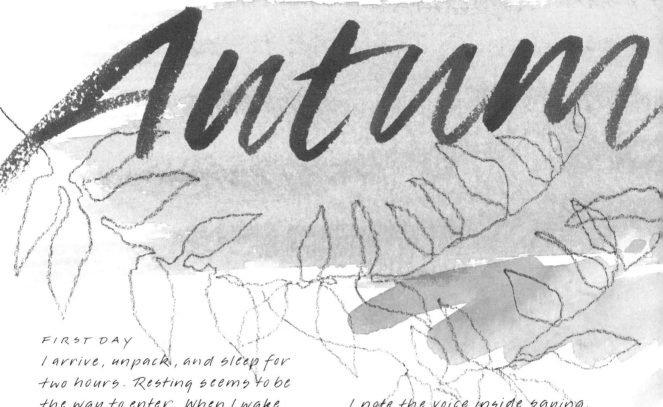

Autumn

FIRST DAY

I arrive, unpack, and sleep for
two hours. Resting seems to be
the way to enter. When I wake
it is late afternoon and raining.
I have returned to the same cabin,
the same silence, a different season.
I am feeling my way, cautiously,
carefully, gently. The weight of
expectation hangs around.
I need to take it very easy.

I sit by the front window drink-
ing tea and sketching the shrub
textures outside. The wind blows
the branches, flipping the leaves
and showing their silvery under-
sides. I draw the leaves in
blind contour, not looking down at
the page, my eye slowly traveling
the path of the edges. My pencil
follows along on the page.
Not checking back gives a loose
line — a relaxed beauty.

I note the voice inside saying,
"Too easy and therefore not
worthwhile." I ignore it.

On a walk at twilight I come
upon three deer in the back
meadow. I stand still and watch.
Two of them sense me but do
not move away. A light rain
is falling. The youngest one is
sitting in the tall grasses.
I back slowly out of view.

The rain begins to fall harder
in the evening. Inside the warm
cabin, I think of the deer out
there in the dark, in the weather,
finding their warmth and
protection in natural things.

I could never do that.

48

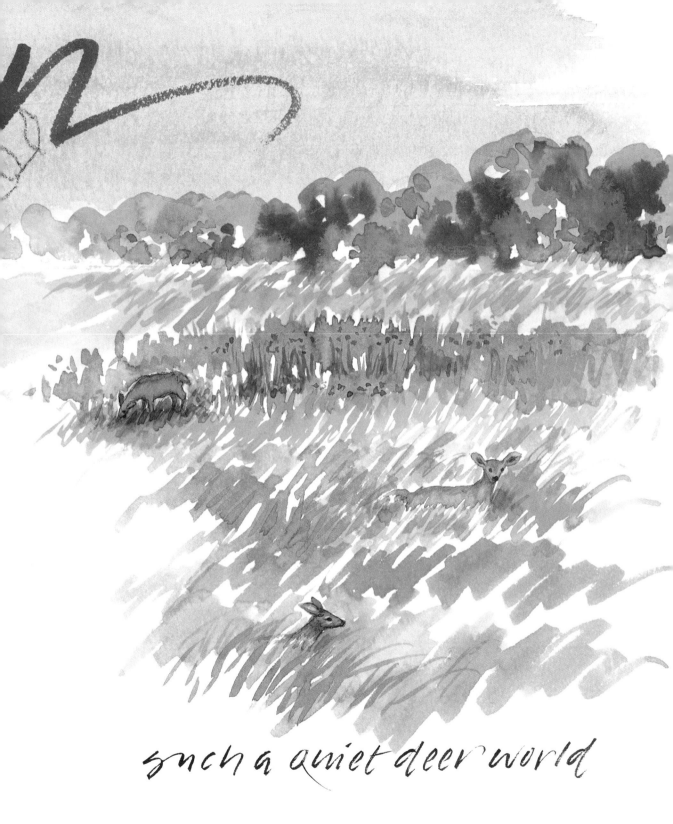

such a quiet deer world

Shifting lines in the sky.
Canada geese overhead
honk their ever-changing connection.
My head goes up—
 an age-old pause in activity,
 lifting one's sights.

SECOND DAY
I sit out in the sunny meadow.
Field crickets are singing all
around me; the air pulses
with their chirps.
A dark daddy longlegs
strides past. I hold one leg
gently. It struggles, then
becomes quiet as I count
and draw. When I let it go,
it picks up its stride again
and disappears quickly
into the grass.

Two monarch butterflies
pass by. I draw them fast.
They never pause.
Are they getting ready for
that long migration south?

Eight legs
Two pair short
Two pair long

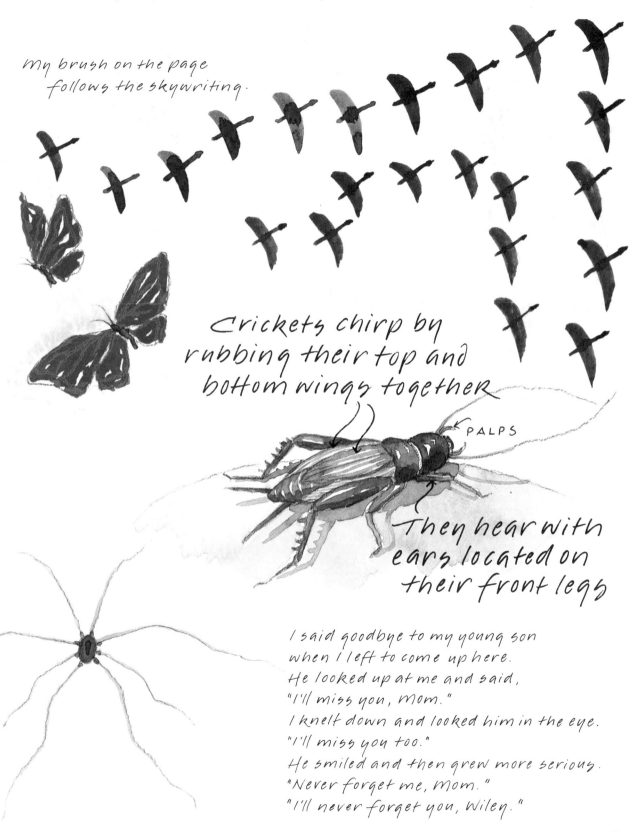

My brush on the page
follows the skywriting.

Crickets chirp by
rubbing their top and
bottom wings together

PALPS

Then hear with
ears located on
their front legs

I said goodbye to my young son
when I left to come up here.
He looked up at me and said,
"I'll miss you, Mom."
I knelt down and looked him in the eye.
"I'll miss you too."
He smiled and then grew more serious.
"Never forget me, Mom."
"I'll never forget you, Wiley."

51

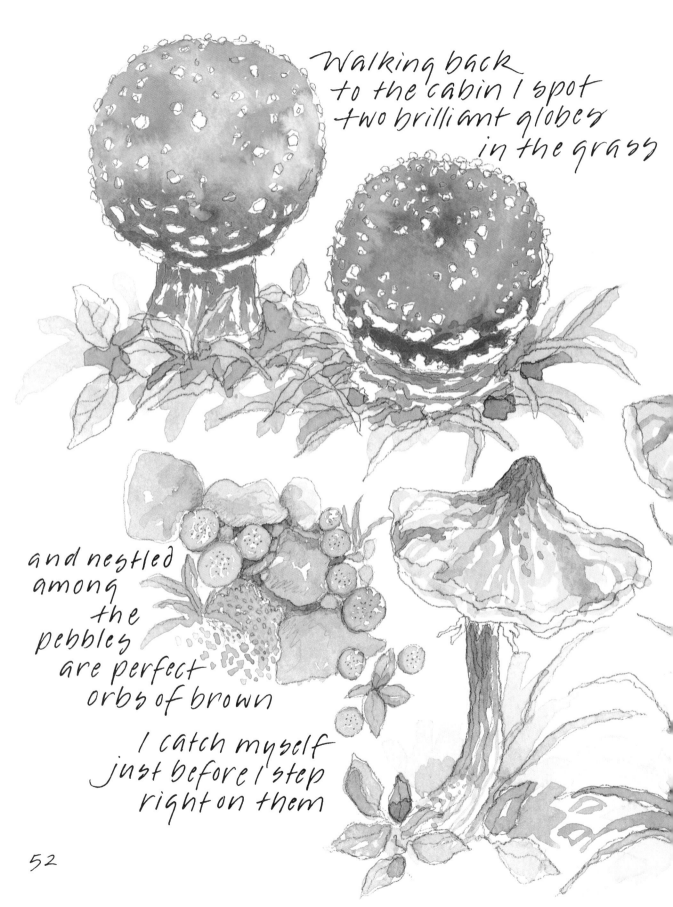

Walking back
to the cabin I spot
two brilliant globes
in the grass

and nestled
among
the
pebbles
are perfect
orbs of brown

I catch myself
just before I step
right on them

52

I walk on slowly, musing about these mushrooms. They are like fruits, each one connected to a vast tree of fungi weaving through the earth under my feet. This is the unseen fabric of the world, stretching deep inside the rotting log and the dark refrigerator, living in the folds of our skin, floating through the air— microscopic fungal threads winding through the world.

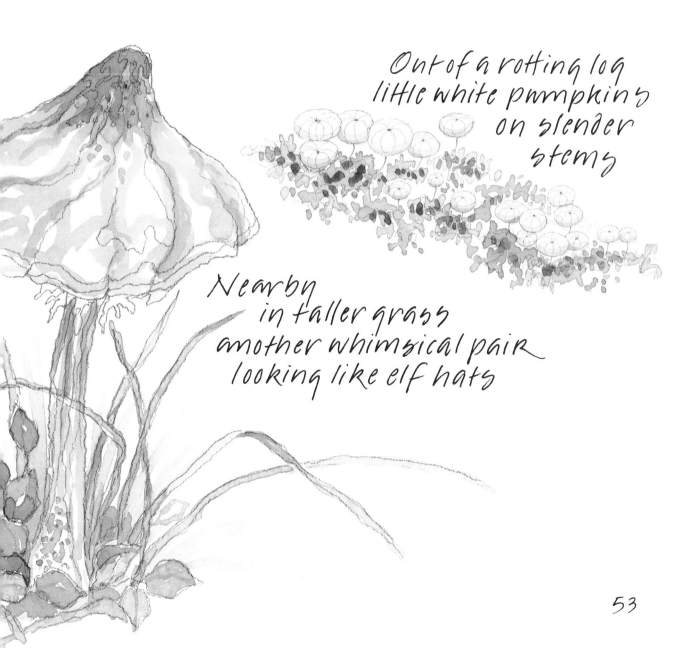

Out of a rotting log
little white pumpkins
on slender
stems

Nearby
in taller grass
another whimsical pair
looking like elf hats

53

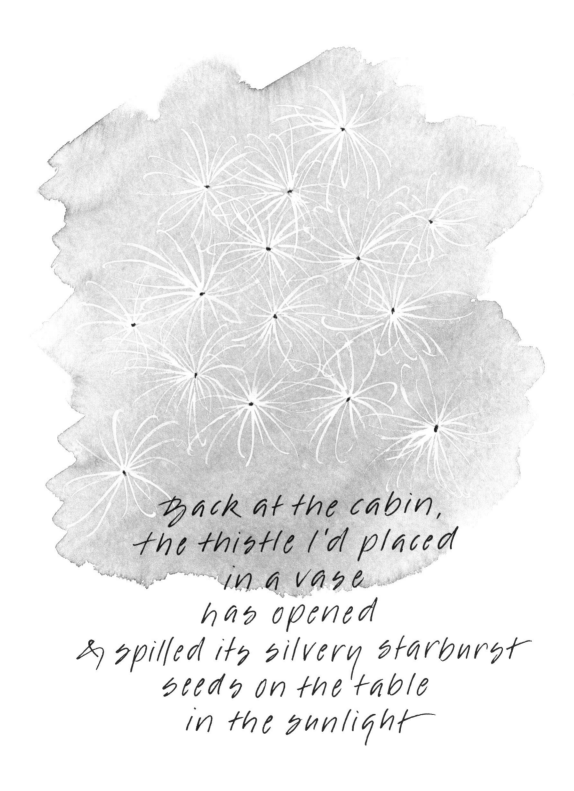

Back at the cabin,
the thistle I'd placed
in a vase
has opened
& spilled its silvery starburst
seeds on the table
in the sunlight

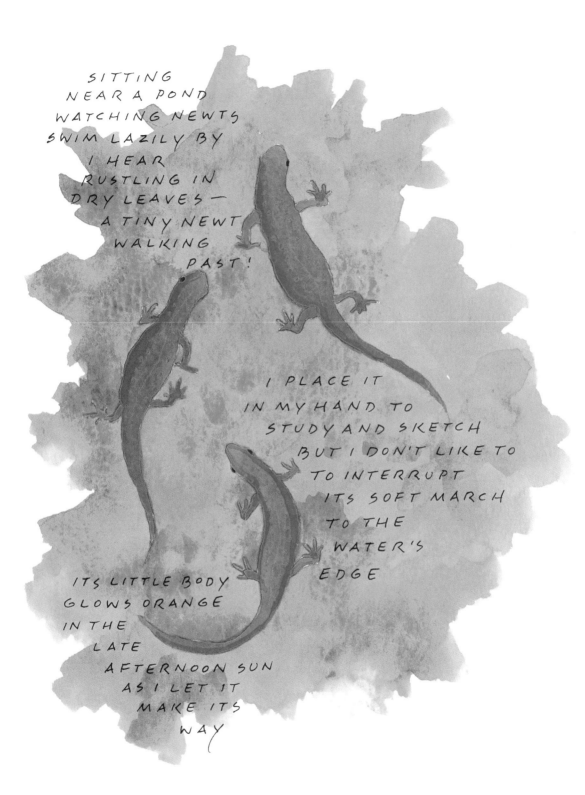

SITTING
NEAR A POND
WATCHING NEWTS
SWIM LAZILY BY
I HEAR
RUSTLING IN
DRY LEAVES —
A TINY NEWT
WALKING
PAST!

I PLACE IT
IN MY HAND TO
STUDY AND SKETCH
BUT I DON'T LIKE TO
TO INTERRUPT
ITS SOFT MARCH
TO THE
WATER'S
EDGE

ITS LITTLE BODY
GLOWS ORANGE
IN THE
LATE
AFTERNOON SUN
AS I LET IT
MAKE ITS
WAY

I come upon
a stand of goldenrod
covered with bees.
As I start to sketch
the bees become quieter,
methodically dipping
into each flower...
then suddenly
everyone is
frantically
jumping around
and buzzing.
My pencil lines quiver too.

Then I step back to watch.

The bumblebees are
yellow and black.
The honeybees are
a little smaller
with a band of
rust-colored fur
across their backs.

Some small flies
are here too,
rubbing their front
legs together.

Two different
types of bees,
two different
types of wasps,
some bluebottle
flies, all working
the golden flowers.
Are they busier now,
sensing the
closing down
of the season?

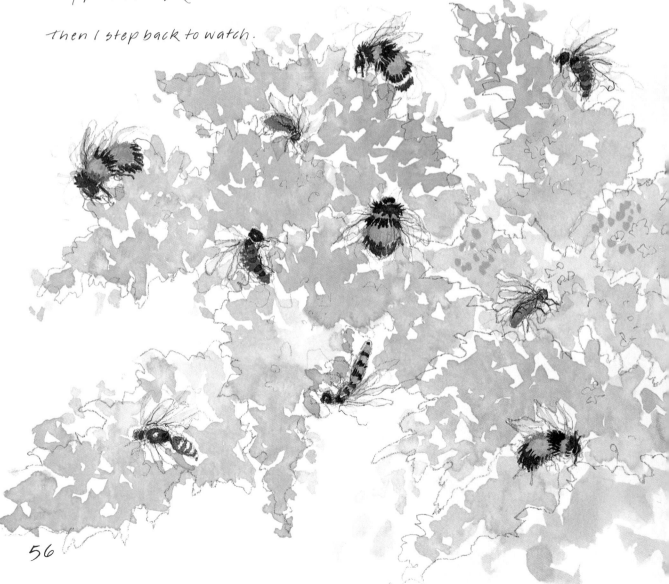

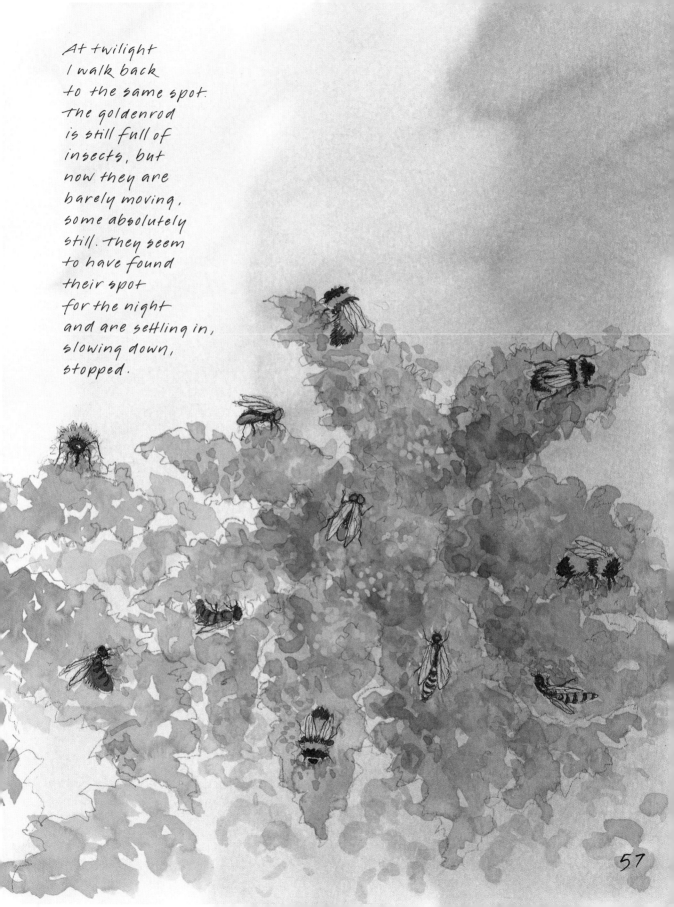

At twilight
I walk back
to the same spot.
The goldenrod
is still full of
insects, but
now they are
barely moving,
some absolutely
still. They seem
to have found
their spot
for the night
and are settling in,
slowing down,
stopped.

57

THIRD DAY
I feel this push to acquire more,
 to get more down on the page,
 to learn the names,
 to define the shapes,
 to capture the colors.
And then that shaky voice
 comes in —
 "I can't do it.
 I can't get it right.
 Someone, somewhere,
 will find me wrong."

 Sadness.
 Late afternoon.
 I'm doing all I can.
 Why this need to do more?

The sadness is a weight inside,
 the weight of the heart.
 Sadness is its covering
 and protection.
If I am willing to feel the sadness
 then the door can open softly.

Along a path seldom walked
 by anyone I pass a stand of ferns
 growing deep in the shade
 of an old spreading fir.
I stop and look at them,
 all thick and green and soft,
 and I think,
 everything in this world
 deserves to be seen and greeted.

The eighth-century Chinese poet Tu Fu
 wrote thousands of poems.
 None of them were read
 or recognized during his life.
 Three hundred years later
 he was finally seen.

58

A chipmunk
watches me from
a window in its
stone-wall
habitat

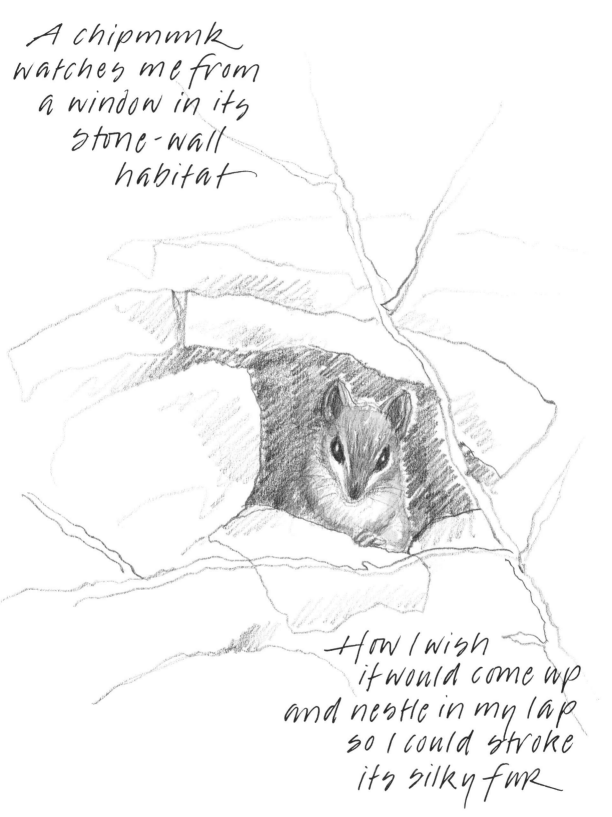

How I wish
it would come up
and nestle in my lap
so I could stroke
its silky fur

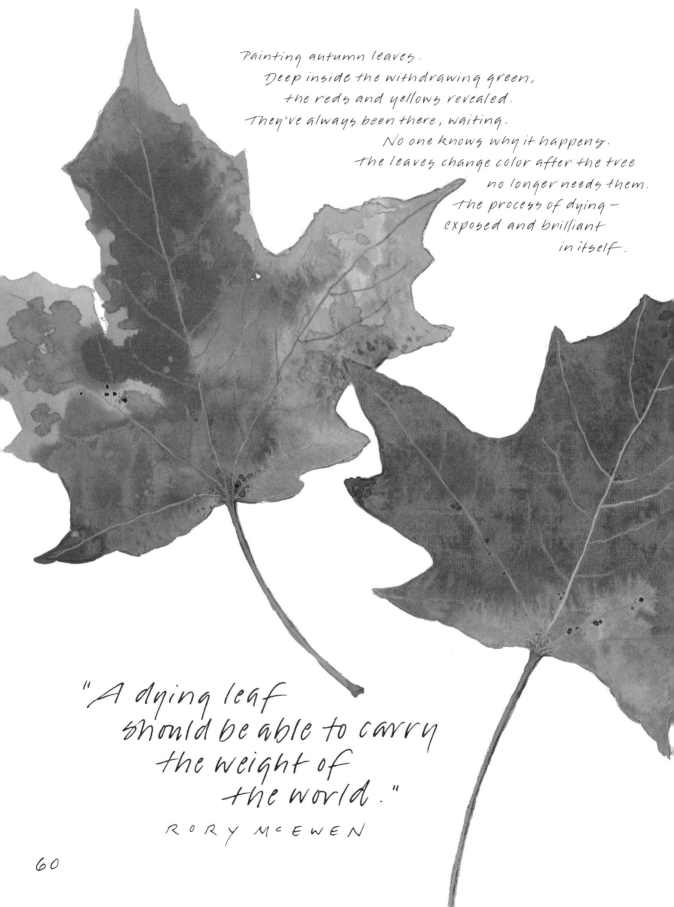

Painting autumn leaves.
Deep inside the withdrawing green,
the reds and yellows revealed.
They've always been there, waiting.
No one knows why it happens.
the leaves change color after the tree
no longer needs them.
the process of dying —
exposed and brilliant
in itself.

"A dying leaf
should be able to carry
the weight of
the world."
RORY McEWEN

60

As the leaves fall,
autumn is slipping
through my fingers,
the colors fading away.
It hurts to see it go.
I don't want to be holding on
to the beauty of this world.
I want to live my life
open-eyed and full.

At twilight I walk along
the edge of the woods
and peer into the dark
trees and undergrowth.
I am afraid of the night woods,
afraid of someone hiding
there, afraid of what
I can't see.

Could I go into that darkness
to experience the discomfort
and edginess and fear?
Could I be curious to
see what it is?

FOURTH DAY
Sitting practice.
Loosening up the familiar,
the deeply known ruts of thoughts.
Opening for a moment to a bigger landscape.
Wandering off and coming back, over and over, to right now.
Coming back from the thought, the belief,
that I must do something, become something.
For a moment just being alive is enough.
Dreaming off and away and returning.
Gentle mind. Wild mind. Relaxed mind.
Gaze follows the line of the cloth,
the reflection in the water bowls,
then mind wanders off into worry.
There is no one here pressuring me for anything.
Where does the pressure come from?
The undertow of my own expectations pulls me off
and into a panic. Coming back to the breath. Out and in.
This is too much, I can't get my life in order,
all the rows of plants in ordeR.
I'm the sort of person who — this nearly freezes me,
I know what's coming — I'm the sort of person who
will not take a chance, dive down deep,
stay out late in the dark. These beliefs tighten.
I come back to the breath as it goes out,
I look at the picture on the table of Trungpa Rinpoche
making that big black brushstroke, the ink flowing,
the rain falling, the day unfolding.
I have to get to work, have to focus, have to, have to.
Coming back, coming back.

One bird singing in the rain.

63

The sky clears and I head outside.
I walk along with an anxious,
excited energy churning through me.
What will I come upon?
Will I tighten up when I start to draw
or can I let my line relax?

As I sit down to sketch
the cottonwood overhead, it is
the stillness that strikes me first.
There's only the sound of the pencil
moving across the page.
Then I hear the wind
and a squirrel chirring softly,
and I notice the spiderweb glistening.
This is the journey of drawing.
Sitting down and allowing awareness
to shift. It doesn't really matter
what happens on the page.
Just the act of drawing
slows me down, opens me up
each time I touch the paper.

Birds calling out
Sunlight in the woods
Happiness

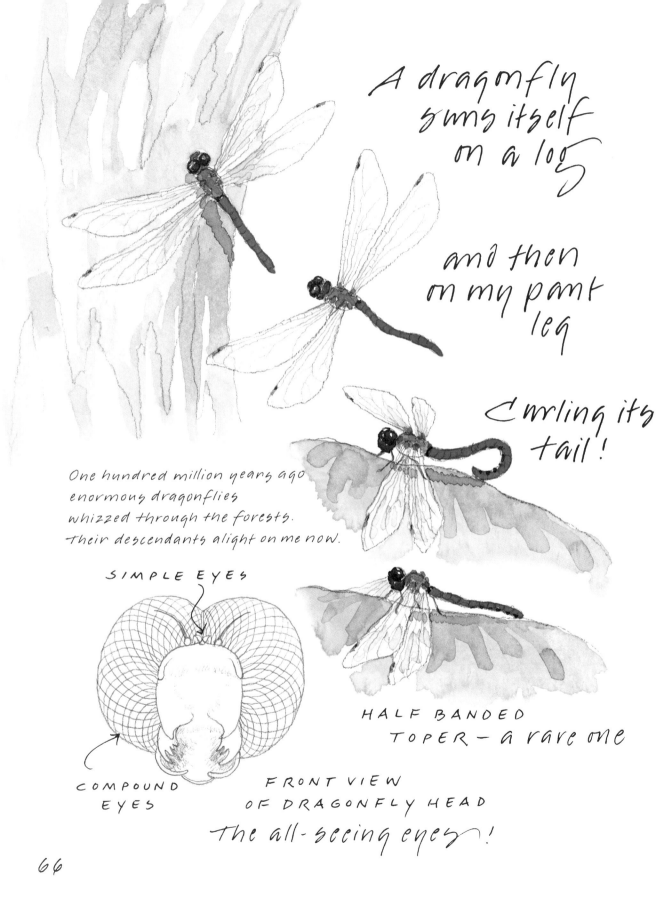

A dragonfly suns itself on a log

and then on my pant leg

Curling its tail!

One hundred million years ago enormous dragonflies whizzed through the forests. Their descendants alight on me now.

SIMPLE EYES

COMPOUND EYES

HALF BANDED TOPER — a rare one

FRONT VIEW OF DRAGONFLY HEAD

The all-seeing eyes!

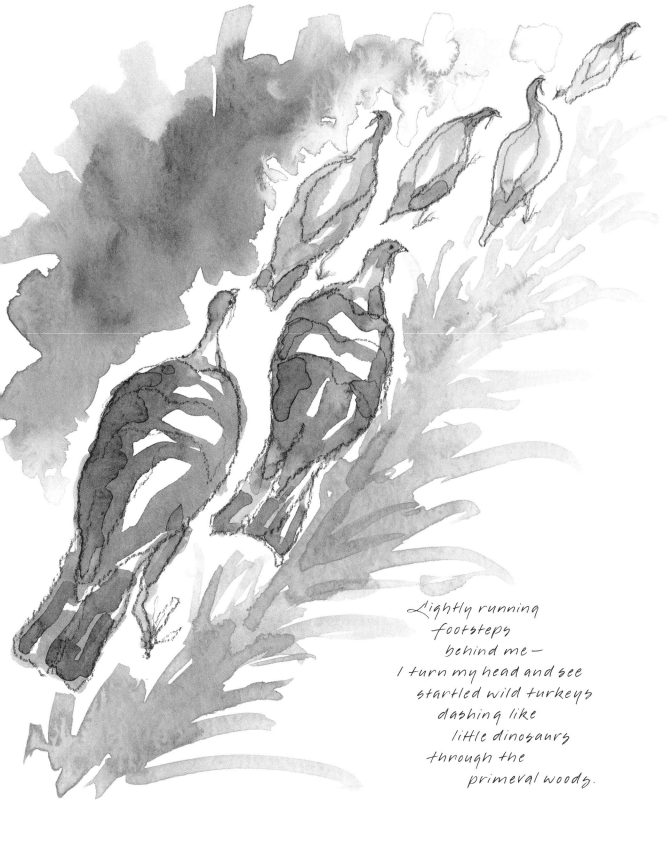

Lightly running
footsteps
behind me —
I turn my head and see
startled wild turkeys
dashing like
little dinosaurs
through the
primeval woods.

67

As I walk down out of the woods,
the path opens onto a field,
 a brilliant hillside and beyond—
 My brush describes it all

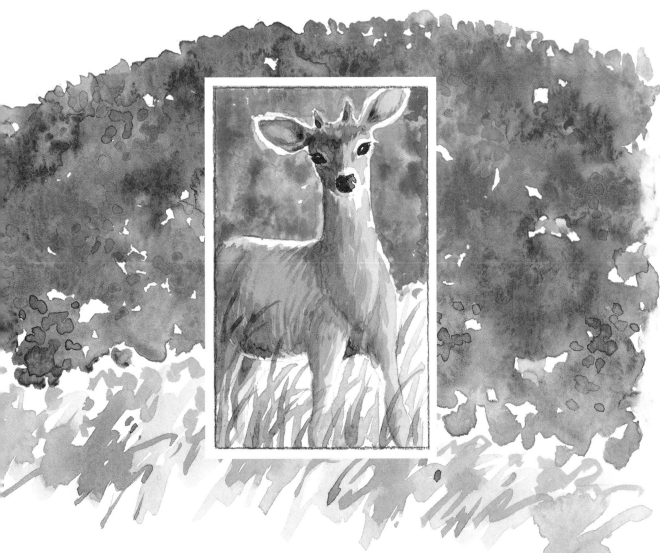

I stand in the middle of the field with the sun going down
and everything is warmed with the slanting light.
A solitary deer tentatively walks towards me, closer
and closer. I am ready for him, ready to reach out and
feel his smooth back. But what if he comes close?
I long to touch his warm body. I am afraid of his sharp kick.
He takes another step, then another. I am held in the moment.
Then suddenly it is too close and the spell is broken.
He leaps away and I hear his hard hooves hit the ground
and watch the white tail waving back and forth
as he disappears into the woods.

69

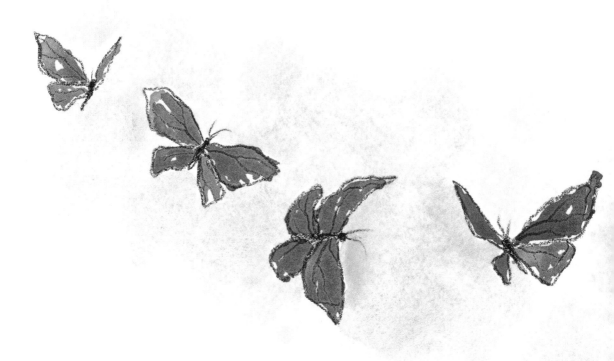

FIFTH DAY

The monarchs arrive again,
 beating their wings slowly
 in the sunlight.
The seem in no hurry to move on
from this wonderful thistle.

 Drawing things that move
 makes me happy,
 loosens my line,
 awakens love.

I believe it is these
 same two butterflies
that I have been watching
 for the past five days.
 And now, at the end,
 they have paused
 and are giving me
 all the attention
 I could hope for.

Later in the evening I sit out on the porch
 and watch the wind blow across the meadow.
The moon comes out and the dark trees move
 together and everything is moving and
 whispering and humming with life.

monarch
pause

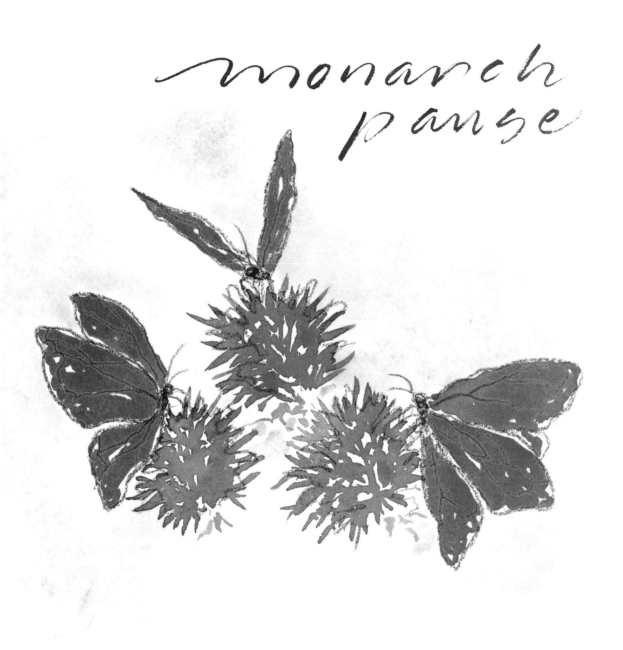

Caterpillar on the ledge

SIXTH DAY
On the last morning,
a soft yellow caterpillar
moves across the porch.
It has five black tufts
sticking out and up.

Creatures keep showing up
as I'm trying to leave—
"Draw me! Draw me!"

CURLED UP
IN MY HAND

And here
it goes,
heading down
the wall
showing its
little black
rear end

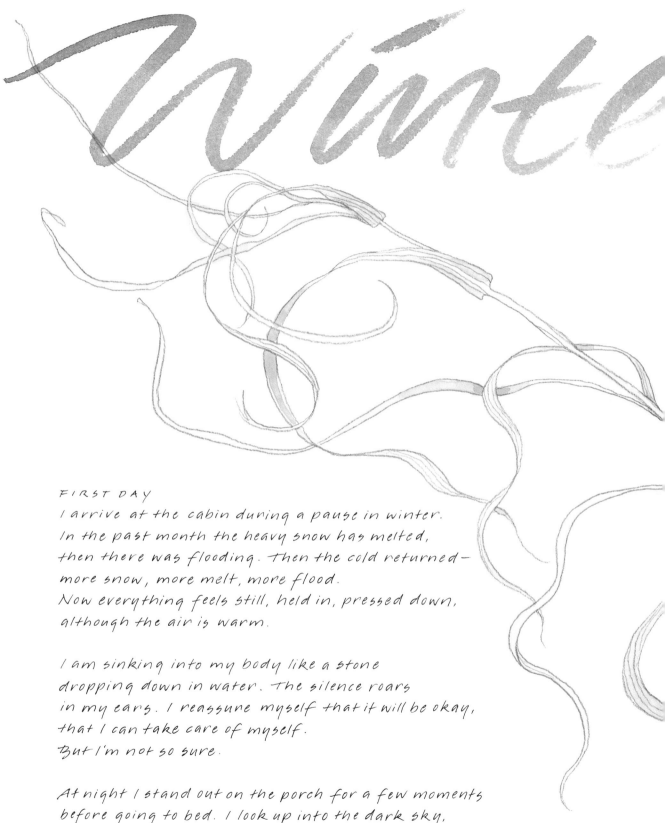

Winter

FIRST DAY

I arrive at the cabin during a pause in winter.
In the past month the heavy snow has melted,
then there was flooding. Then the cold returned—
more snow, more melt, more flood.
Now everything feels still, held in, pressed down,
although the air is warm.

I am sinking into my body like a stone
dropping down in water. The silence roars
in my ears. I reassure myself that it will be okay,
that I can take care of myself.
But I'm not so sure.

At night I stand out on the porch for a few moments
before going to bed. I look up into the dark sky,
my arms crossed, breathing in the cold air, shivering.

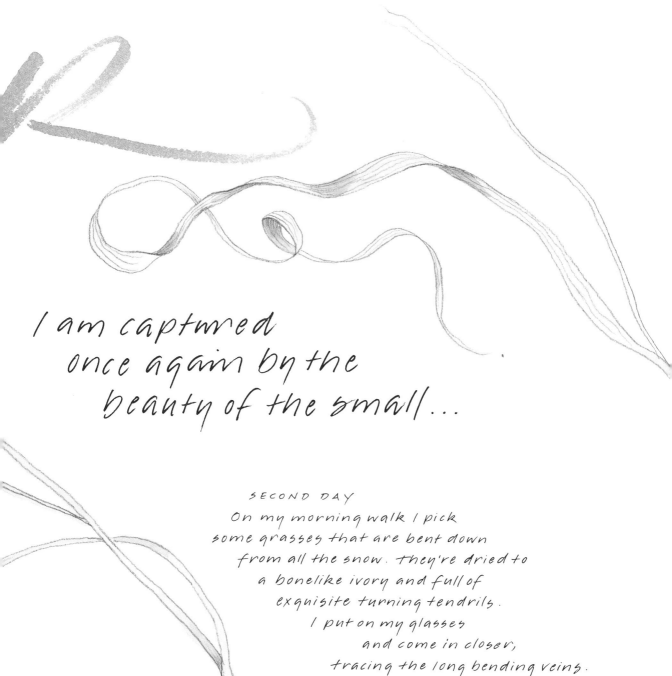

I am captured
once again by the
beauty of the small...

SECOND DAY
On my morning walk I pick
some grasses that are bent down
from all the snow. they're dried to
a bonelike ivory and full of
exquisite turning tendrils.
I put on my glasses
and come in closer,
tracing the long bending veins.

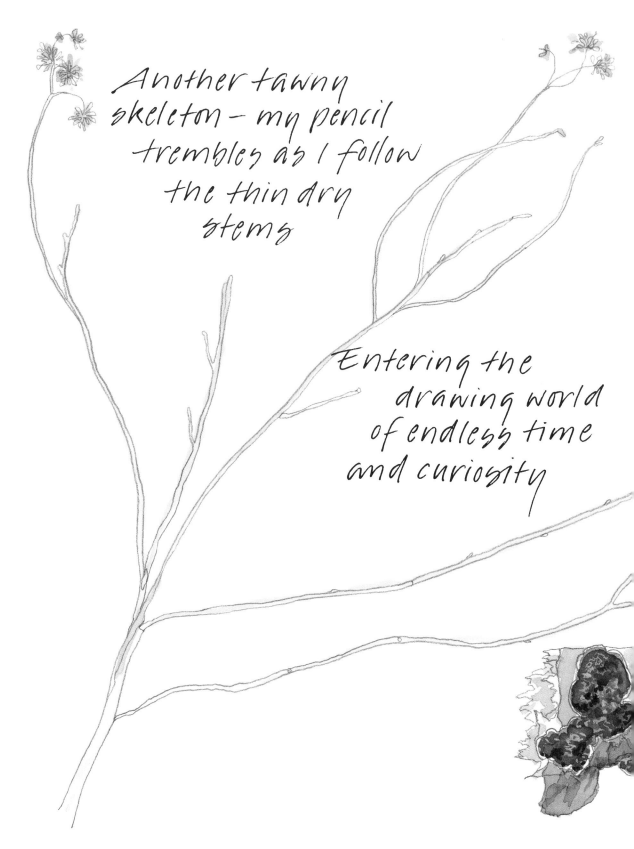

Another tawny
skeleton – my pencil
trembles as I follow
the thin dry
stems

Entering the
drawing world
of endless time
and curiosity

Everything becomes worthy of study and affection

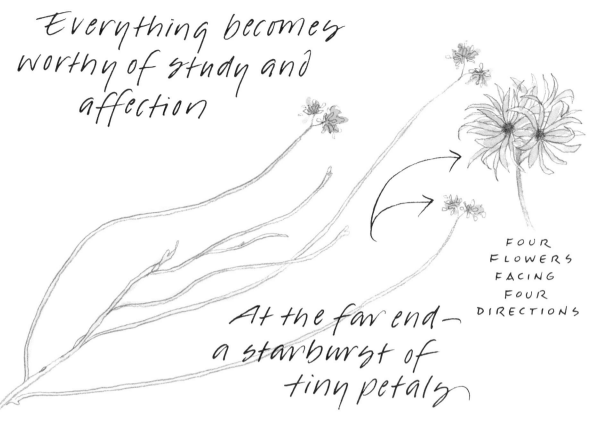

FOUR
FLOWERS
FACING
FOUR
DIRECTIONS

At the far end—
a starburst of
tiny petals

I paint sitting on the porch. My hands and feet are cold but my mind is full of crow calls and bare branches rustling.

Before going to sleep I step outside and then walk down off the porch. I stand a little way from the cabin, holding myself tightly.

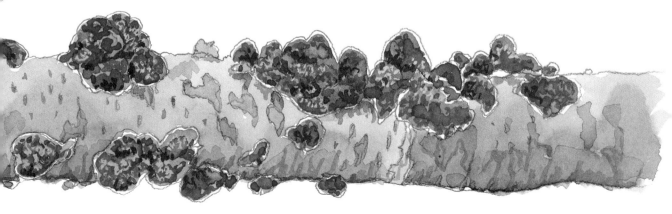

Walking the miniature landscape of fungi on this broken branch.

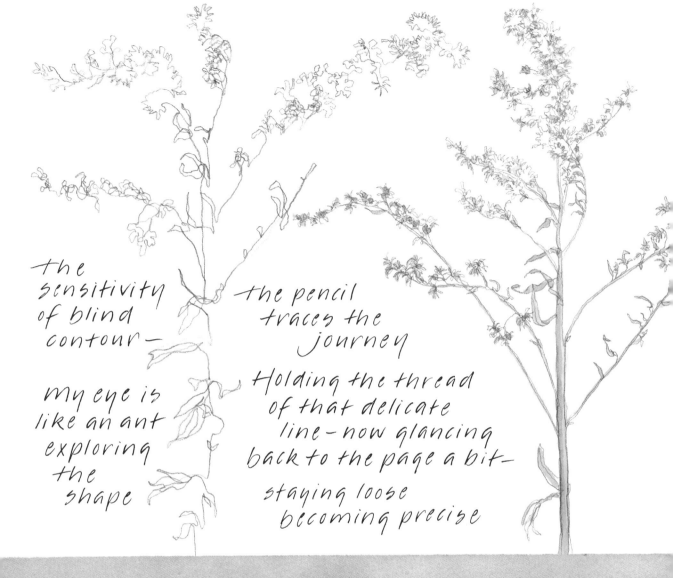

the
sensitivity
of blind
contour—

my eye is
like an ant
exploring
the
shape

the pencil
traces the
journey

Holding the thread
of that delicate
line—now glancing
back to the page a bit—
staying loose
becoming precise

THIRD DAY

After a restless night, with my sleep interrupted by strange
sounds, I wake up early, sit for an hour, and fix myself
breakfast. The first sign of bird life is the hollow tapping of a
woodpecker working the old trees out in the meadow. I can see
it move from tree to tree, flying in long dips. An unknown
bird sings a two-tone descending call. I step out onto the porch—
can't do it quietly because of the squeaky door—and see a hawk
pass by with crows in mob pursuit. Then they all fly away and
it's quiet again. I notice the seeds that I scattered on the porch
railing last night have vanished. Who is the night visitor?

Beginning to
understand what
makes up
the party —

As I draw,
snow moves
across the hills
toward me,
wind
swirling
the flakes

THE
TIP
OF A
STEM

↓

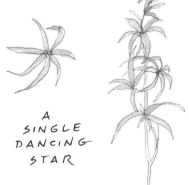

A
SINGLE
DANCING
STAR

These single stars
are the underpetals,
thrown open in release,
the silky stamens
still clinging like fur

After lunch I take a walk. I head into the woods to the east
and find a stand of tall, slender trees deep in the forest.
I sit underneath, watching them sway wildly in the wind,
then retrace my steps and come upon a broad path that seems
to lead back to the cabin. I follow it briskly, confident of finding
my way around this land. The path leads to an open field and
a dairy farm I've never seen. I keep going, sure that the cabin
will appear just around the bend. Then it begins to snow. I come
upon a gravel road and an empty, unfamiliar house. I keep
walking, realizing I'm lost.

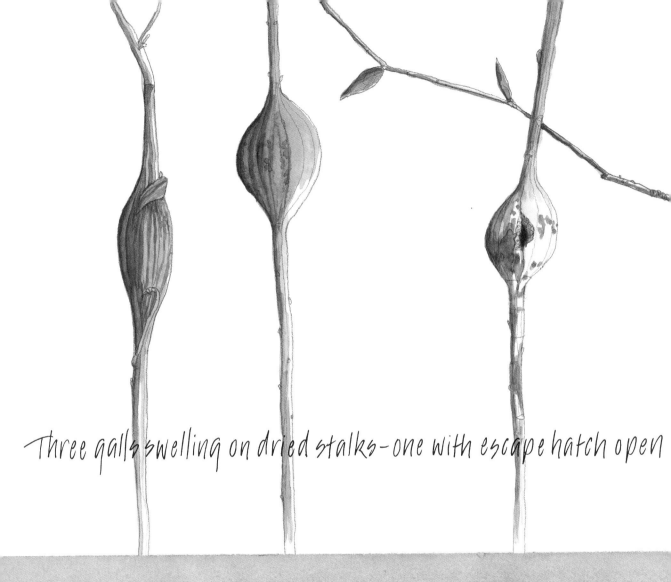

Three galls swelling on dried stalks—one with escape hatch open

A car drives by with three men in it. They stop and I ask the driver if he knows the retreat land. He doesn't. I turn down the offer of a ride and keep walking up and over a hill, scanning the horizon for anything familiar. The snow is coming down thick now. I remember my adventurous brother saying to me, "It's good to get lost once a day." This is briefly comforting, but now it's dark and I'm scared. Then the car with the three men returns. They are concerned and have come back to find me. I accept their ride this time and within a quarter mile I see the prayer flags at the bottom of the driveway. I get out and tell the men they are my guardian angels.

80

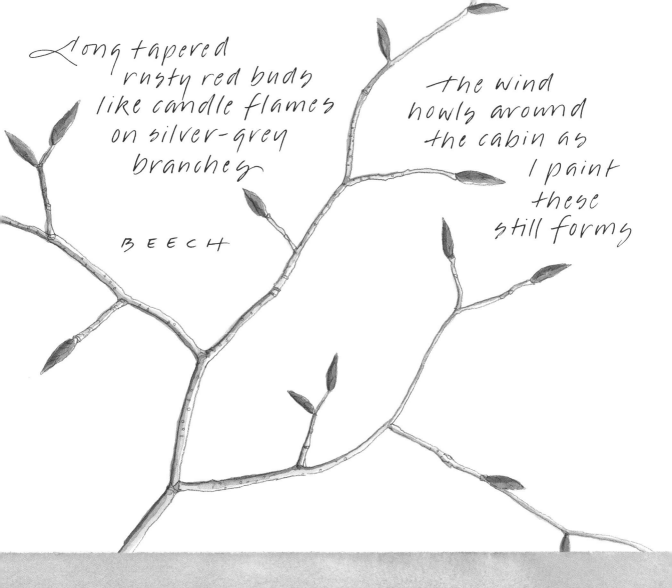

Long tapered
rusty red buds
like candle flames
on silver-grey
branches

The wind
howls around
the cabin as
I paint
these
still forms

BEECH

In our brief conversation I also tell them I am the only one up here
right now. I walk up the hill to the cabin. Now my mind has turned
these angels into stalking rapists. Fear circles me, peering in the
windows, breathing at the door. A woman alone at night: vulnerable.
My clenched mind grabs and holds and pulls me down. I have to
break out and away. I bundle up and step out the door. I walk out
into the middle of the dark field, all the way to the big oak tree,
the farthest I've ventured yet. I touch its thick rough bark,
take some deep breaths, and walk back. I make no promise to
go farther tomorrow.

FOURTH DAY

After I went to bed last night
the weather turned wild. The wind
gathered and turned and crested
and hit the cabin full force so
that everything shuddered—
windows rattled, doors shook,
unknown objects rolled around.
Then the energy would quiet down,
regroup, and gather again,
flinging itself against my little
ship of a cabin out in the middle
of a wild ocean. I thought of
huge kelp trees being pulled
back and forth in immense
swells. I thought of whales
floating in a world of continual
movement. I remembered the
game Wiley and I used to play,
imagining that we were under
water and everything we saw
as we drove down the road was
an ocean tree, an ocean field,
an ocean fish-bird flying
through space. Last night
the trees were rocked by the
ocean of wind and I lay in bed,
holding on to my body for dear life.

Deep in the night I looked out
the window and saw stars
glimmering in a clear sky,
the clouds all blown away.
The trees swung back and forth
and my heart pounded, but
deep inside me was a quiet
place, protected and calm.

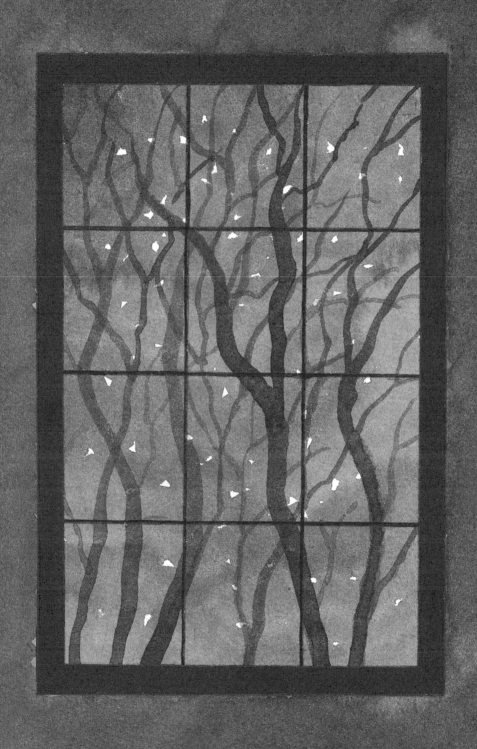

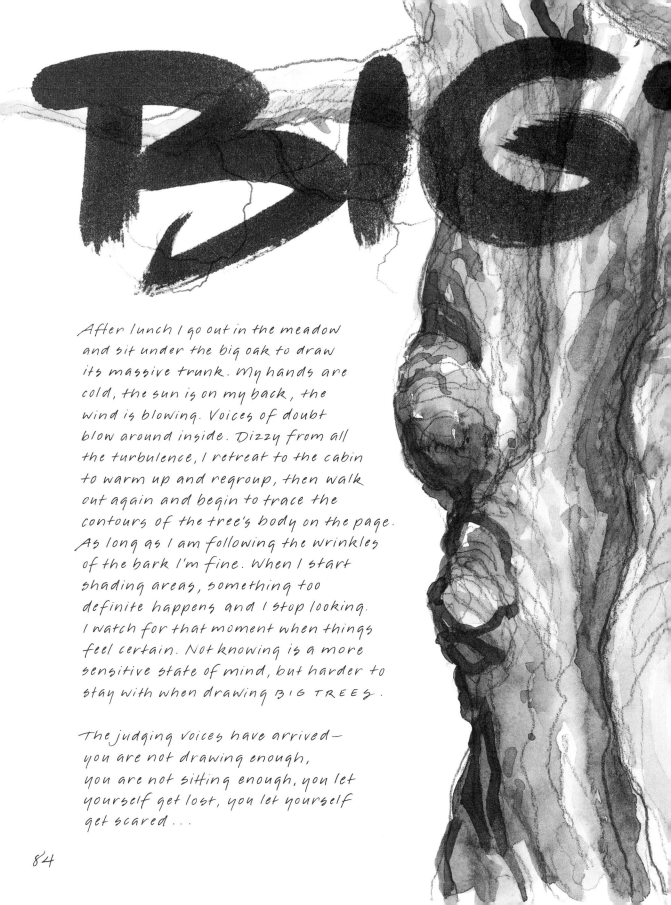

BIG

After lunch I go out in the meadow and sit under the big oak to draw its massive trunk. My hands are cold, the sun is on my back, the wind is blowing. Voices of doubt blow around inside. Dizzy from all the turbulence, I retreat to the cabin to warm up and regroup, then walk out again and begin to trace the contours of the tree's body on the page. As long as I am following the wrinkles of the bark I'm fine. When I start shading areas, something too definite happens and I stop looking. I watch for that moment when things feel certain. Not knowing is a more sensitive state of mind, but harder to stay with when drawing BIG TREES.

The judging voices have arrived— you are not drawing enough, you are not sitting enough, you let yourself get lost, you let yourself get scared . . .

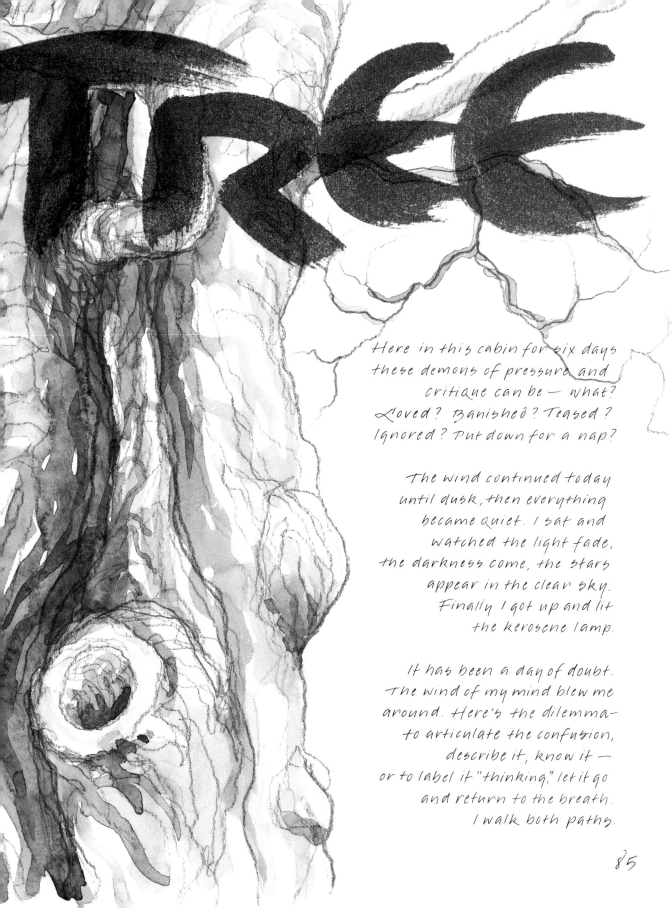

TREE

Here in this cabin for six days
these demons of pressure and
critique can be — what?
Loved? Banished? Teased?
Ignored? Put down for a nap?

The wind continued today
until dusk, then everything
became quiet. I sat and
watched the light fade,
the darkness come, the stars
appear in the clear sky.
Finally I got up and lit
the kerosene lamp.

It has been a day of doubt.
The wind of my mind blew me
around. Here's the dilemma—
to articulate the confusion,
describe it, know it —
or to label it "thinking," let it go
and return to the breath.
I walk both paths.

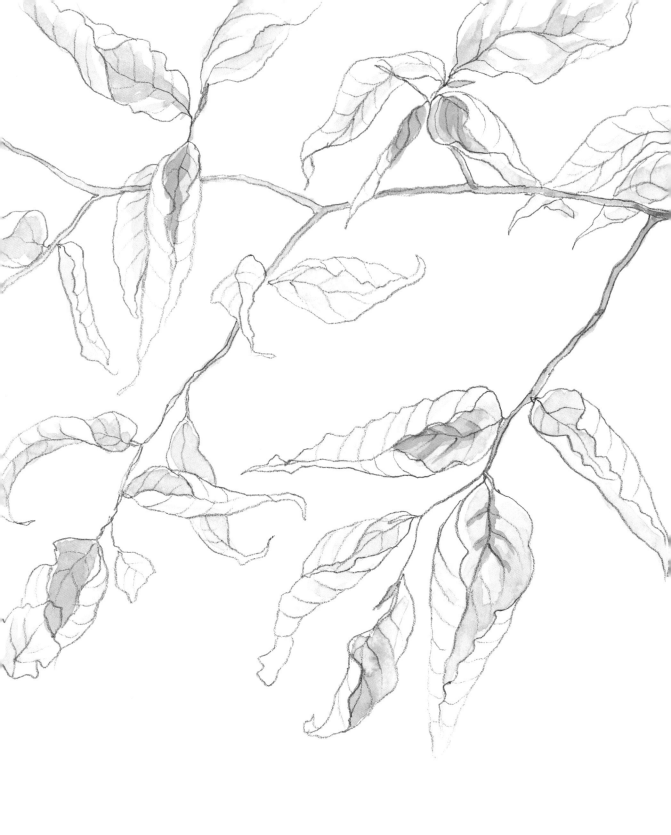

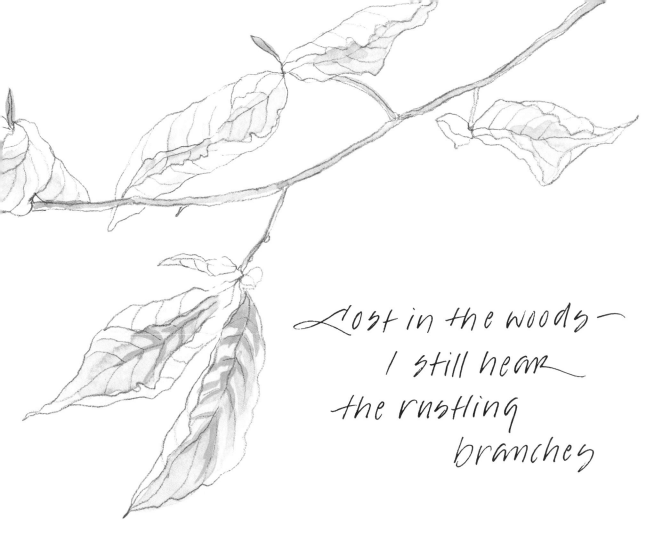

Lost in the woods—
I still hear
the rustling
branches

These are leaves from the saplings that grow throughout the understory of the woods. Their bleached-bone color looks like dappled sunlight in the shade. Drawing them, I return to open mind, full of interest in their delicate curled shapes.

Tonight I walked all the way around the meadow. The quarter moon shone brightly overhead. Many stars out. Quiet cold air. My teeth chattered with the cold and the fear. I hummed the lines from that song about walking through a storm and holding your head up high. By the time I got back to the cabin I was warm and relaxed. I went to bed and slept straight through and deeply.

87

I haven't been able
to attract any
wildlife. No birds
have approached
my feeder. A cat
wandered by but
wouldn't come close.
I saw two deer, but
they were far away.

Having no contact
with creatures
sharpens my
loneliness.

FIFTH DAY
I come upon
a graveyard of
cow bones in the
woods near the
farmer's field,
all white and still.
I pick up a
single vertebra,
turn it in my
hand, and carry
it back to the
cabin to draw.

I learned long ago
to respond to others.
This was my mother's
rich and sensitive
teaching. But there
is no one here to
respond to. I am
shifting a deep
feminine pattern.
Can I be there
for myself?

The aloneness of
death sits with me.
I am nervous in its
presence. I sit in
meditation and
feel the discomfort.
I let it be.

Being by myself
is a preparation for
dying, a practice
of getting familiar
with where it's
all heading.

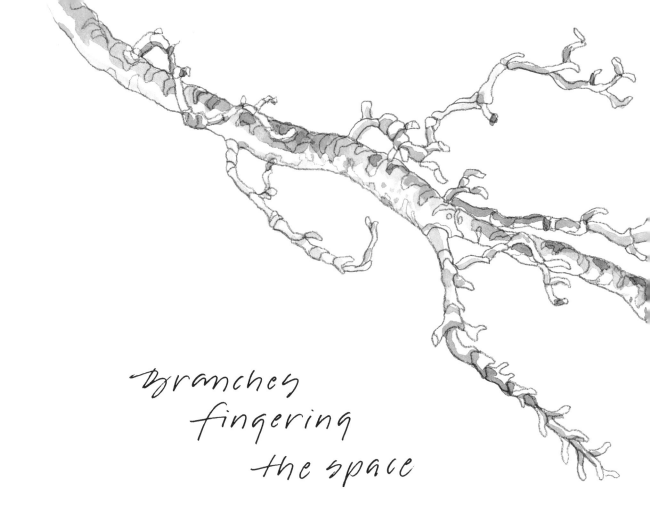

branches
fingering
the space

At dusk, I watch the dark come in.
This is something I seldom do back home,
where the life of the house keeps me preoccupied
It is beautiful and quiet, but it's so stark.
Every move I make reverberates in the space.
This has been a lot of quiet and a lot of ME.
I've had enough! I want to have a glass of wine,
watch a movie, talk on the phone.
I want some distraction! This is not fun.

I don't want to take my night walk tonight.
I feel like an upset child as I write this.
I don't want to push through.
I don't want to overcome this fear.
I don't want to be brave or courageous.
I want to stay in and be safe
and warm and protected.

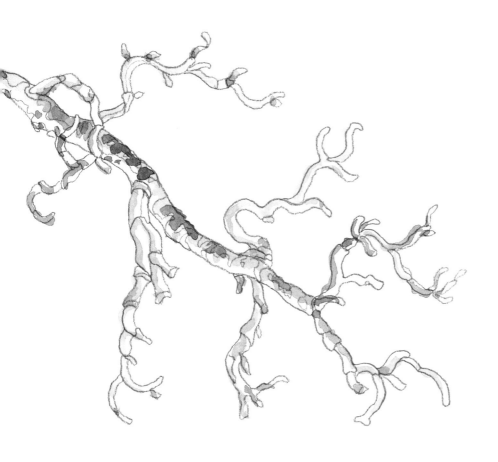

DELICATE
FILIGREE
ORBS ON A
STEM

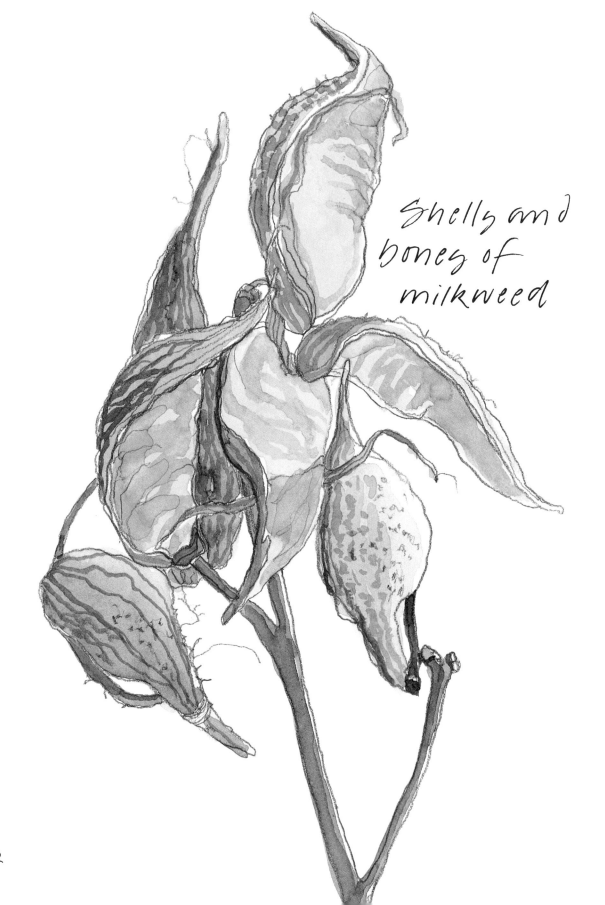

Shelly and bones of milkweed

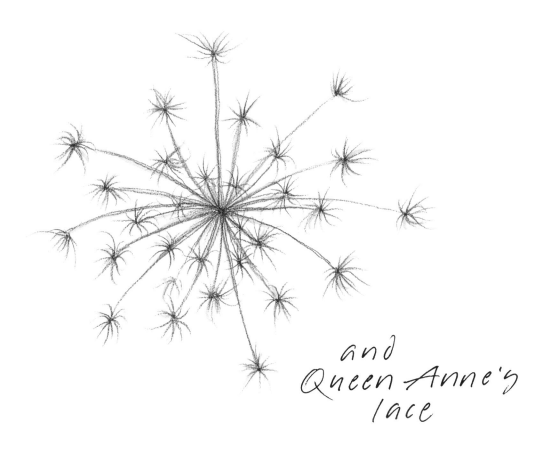

and
Queen Anne's
lace

I feel like I'm letting down all these men in
my life by not having a joyous time here.
I hear their voices:
"Love yourself." (therapist)
"Produce something of value." (agent)
"Go off and do the inner work." (husband)
"You cannot do it wrong." (friend)
I am holding this last one in my mind
as the doubts continue to circle.
I should be feeling something different.
I should be beyond this self-pity.

Tears come and I give in to all of it.

I want to learn something
about myself up here.
I want to be able to pass
it on to others.
But no one wants to hear this.
People want to be inspired by
someone who has gone beyond
all the complaining.

Sitting meditation.
Returning to the breath
again and again,
the outer layers of belief
peel off and raw nerve is exposed.
I imagine being back home and
having a friend comment on how
blissful my retreat must have been
and I slam my hand down on the table
and scream at her —
"You have no idea who I am!"

So nighttime is hard for me.
Is there a place for me in this world
if I don't feel comfortable in the dark?
I need humor with me now.
I need it badly.

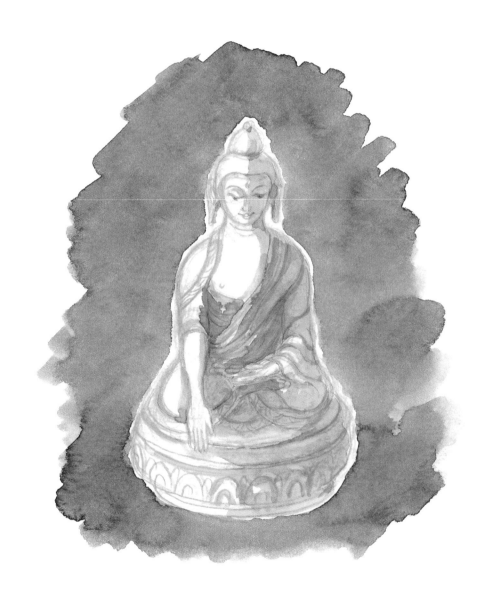

Heard some
rustling outside.
MY HEART
BEGINS
TO POUND. I have to get over this
fear of the dark.
I put on my jacket,
step outside
and nearly walk
straight into a

BIG SKUNK

its white plume of a
tail moving along
the bottom of the
porch steps.

IT IS
EATING
ALL THE
BIRDSEED! WILDLIFE!

So much for that
night walk. I'm definitely
not going out NOW!

So I wanted to
attract wildlife
and I got a
SKUNK— Well I could have
gone out anyway.
That mammal book
said they give warnings
before they spray.

Yes but how
do I know this one
isn't DEMENTED?

Why am I so
mistrustful of nature?
I should have gone out
ANYWAY.

What am I trying
to prove? If there's
a skunk on the front
steps I give myself
permission to
stay in! I feel broken down
worn out
UNABLE
TO
MOVE.

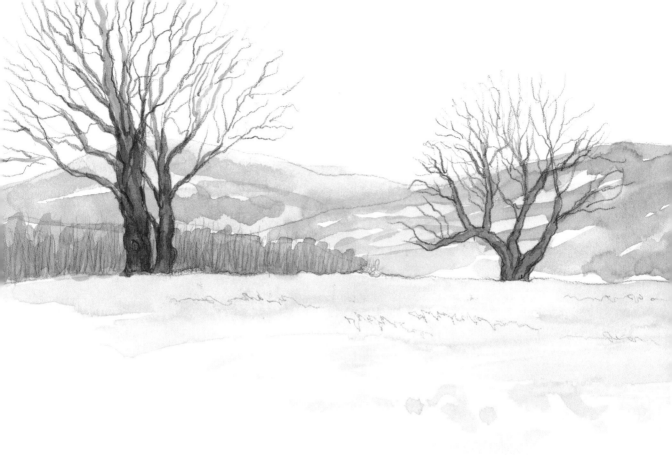

The view across the meadow

SIXTH DAY
Three deer pass by the cabin.
early in the morning. I feel they sense me
through the walls, always alert.

the crows are working the morning meadow.
the swell of their black wings is beautiful.

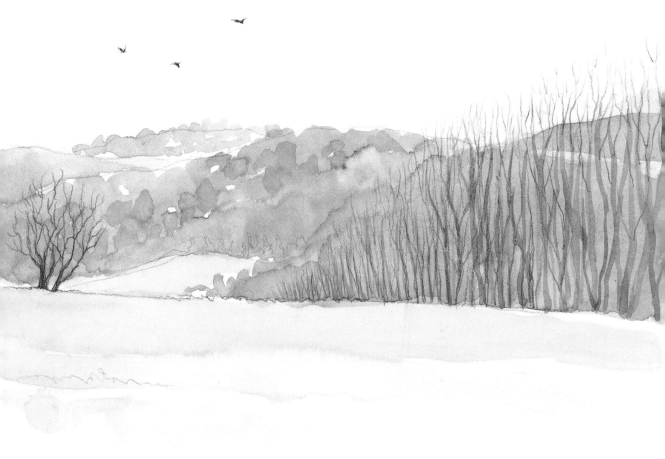

Late winter colors three trees

The sun slides over and sinks down.
Walking. Sitting. Napping. Drawing.
Things begin to soften. I keep thinking about
that big tree out in the meadow and my
frustration with my drawings. I want to
be able to express mass, like shaping a big lump
of clay on the page, and I feel I can't do it.
So I return to my delicate sensitive line.
I do want to try those big shapes again.

that farm cat showed up again
at twilight. I think I could befriend it
if I had a bit more time.

I'm feeling tired and bedraggled
like that old thistle I picked today.

I'll draw it and explore its beauty
and thorniness.

Collapsed thistle
It's tired
I'm tired

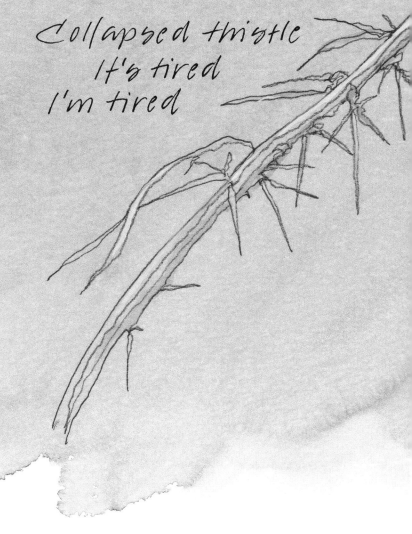

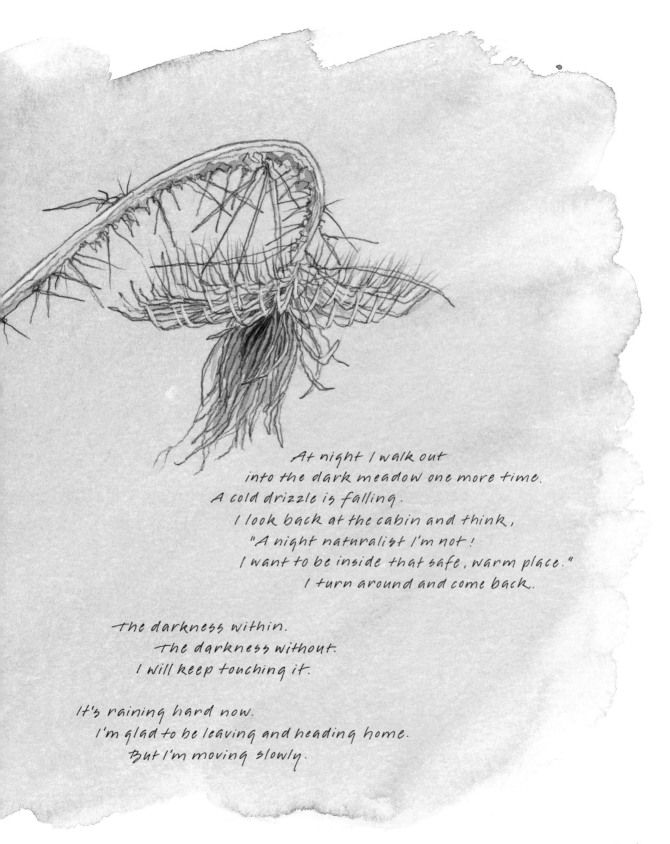

At night I walk out
into the dark meadow one more time.
A cold drizzle is falling.
I look back at the cabin and think,
"A night naturalist I'm not!
I want to be inside that safe, warm place."
I turn around and come back.

The darkness within.
The darkness without.
I will keep touching it.

It's raining hard now.
I'm glad to be leaving and heading home.
But I'm moving slowly.

FIRST DAY

I arrive at the cabin and sit looking out the window across the meadow, out toward the rolling hills bordered by soft, green woods. I bring in all the bags and boxes of food and clothes and art supplies, and then lie down, exhausted from the effort of traveling and arriving. My body begins to unwind and my mind relaxes. I drift into sleep. Then I awake in the dark in a terror that is like drowning. Where is solid ground? Slowly, I bring myself back to this hillside, this cabin, this body. Settling, then agitated, then settling again.

After dinner I sit in meditation. My mind shifts and moves, blinks and itches. I'm heading into that worn-down realm. Just sitting, sitting through it, sitting with it, until the movements of the mind have their own life, until I can't do anything but sit and look and listen.

Here we go again.

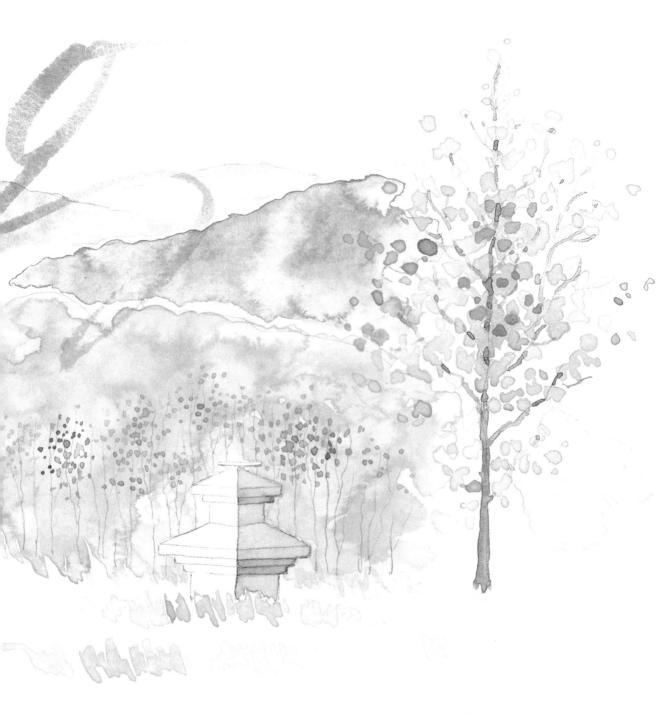

the small stupa
in the meadow—
spring hills all around

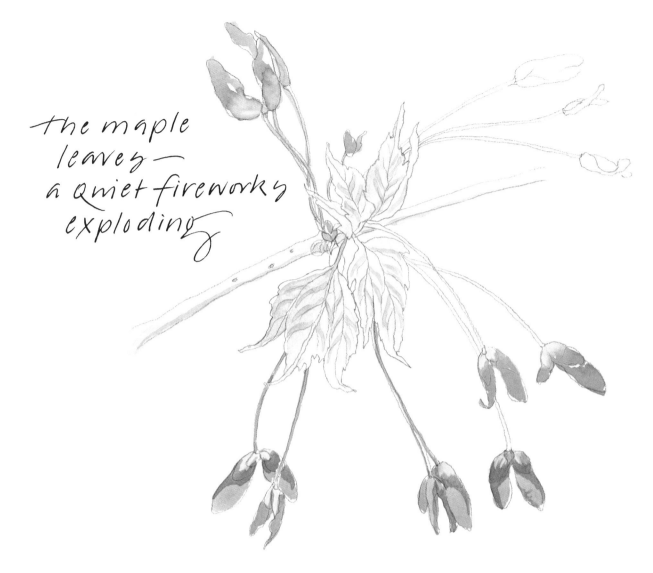

the maple
leaves—
a quiet fireworks
exploding

SECOND DAY

I awaken to birdsong and clear skies. I prop myself up on one elbow in bed and look out the window. Rabbits are nibbling the grass nearby. When I softly clear my throat they freeze in alert.

I dreamt about boundaries, putting borders and frames around things.

I awoke feeling comforted and reassured by the security of containment, the safety of holding things in.

Yet now as I write I am hesitant and unsure of my voice. Life seems so enormous and my perceptions so small. Stay with the small. Stay with the details.

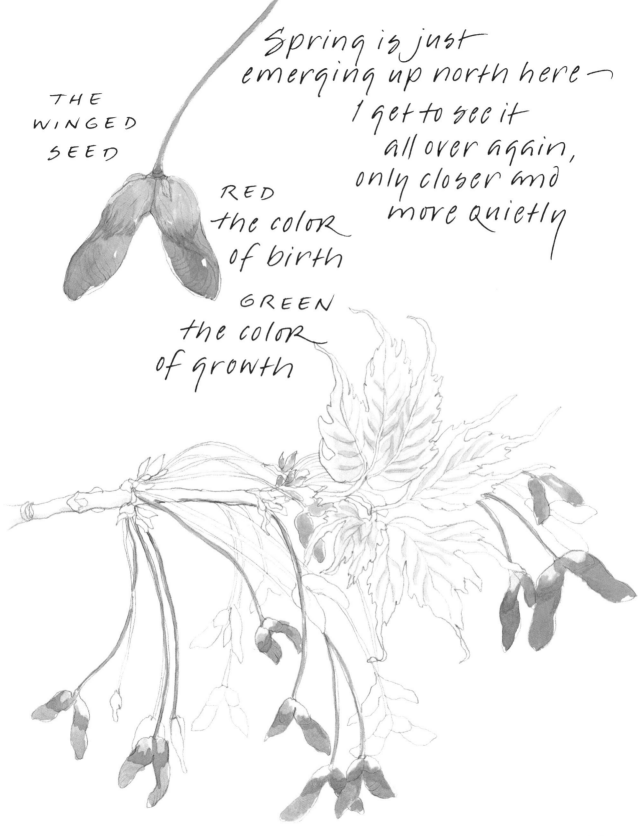

THE
WINGED
SEED

Spring is just
emerging up north here —
I get to see it
all over again,
only closer and
more quietly

RED
the color
of birth

GREEN
the color
of growth

Another opening maple branch—
first like a cornucopia pouring forth

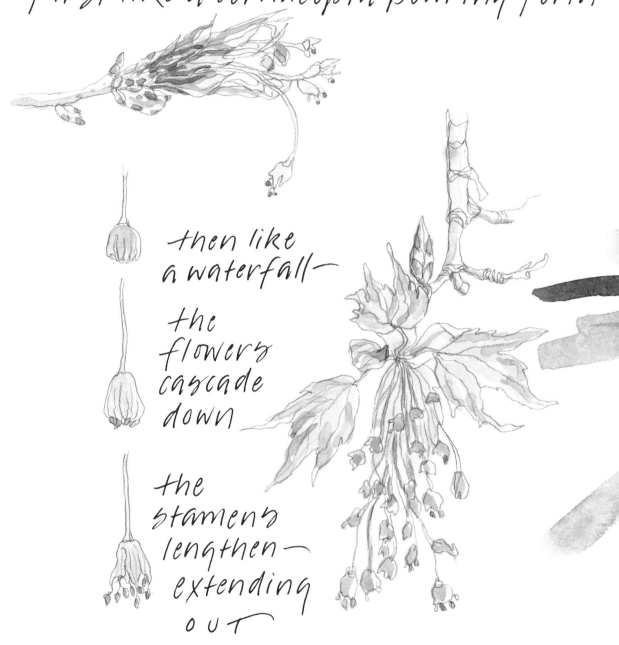

then like
a waterfall—

the
flowers
cascade
down

the
stamens
lengthen—
extending
out

In the morning I walk over to check on the pond where I'd encountered the beaver last summer. I find the whole area slashed and crisscrossed with downed logs — cut with a power saw, not a beaver's tooth. It's a huge mess. The beaver's home is still standing, but all I see is a lone duck paddling around. It is all so damaged.

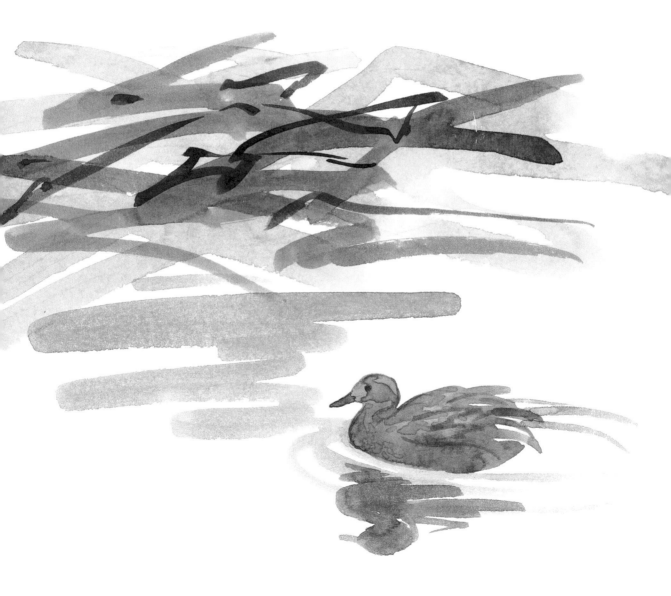

I walk back
across the meadow
and quietly approach
the small cattail pond
behind the cabin.

When my shadow
touches the water
all the tadpoles
dive for cover.

I wait for those shy
tadpoles to return.
This feels like a
hard beginning.
when I discovered
the mess at the
beaver's pond
I felt a deep despair
over the destruction
that humans cause.
Then the tadpoles
swam away
(my presence a
disturbance), and
the sun went behind
the clouds—
everything seems
injured or in hiding.

Big fat tadpoles
in dark waters
on this cloudy
day

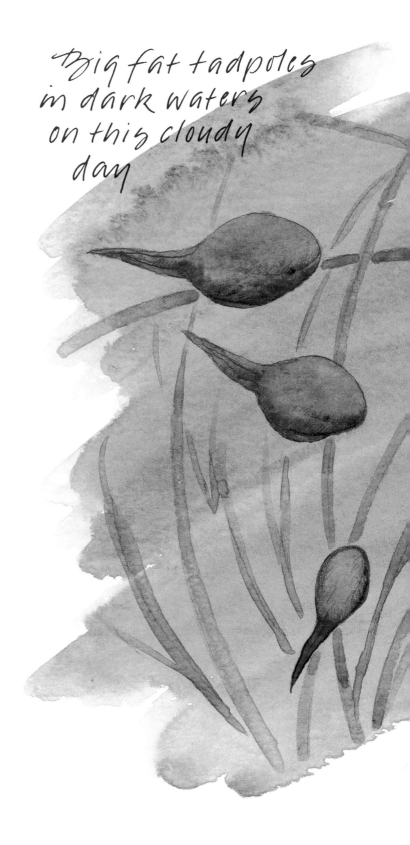

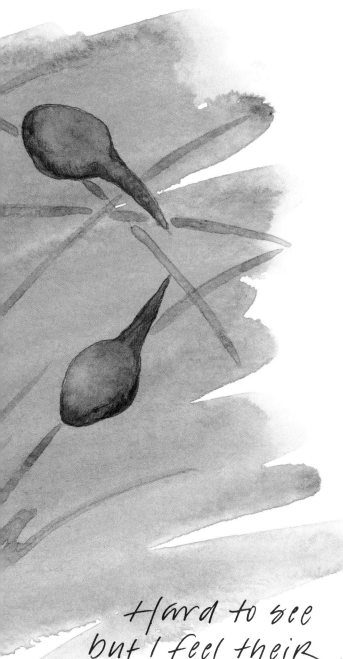

Right now this retreat
feels like a forced march.
I want to crawl into
my burrow and curl up
into a ball, protected
from the night's dangers.

I get into bed at twilight—
stomach tight and
churning, body tense.
I stretch out on my back
and breathe,
gradually relaxing,
my body sinking down
under the covers.

Letting thoughts come
and go, I watch the sky
as it slowly darkens.
I listen to peepers singing
and light rain' falling
just outside the window.

Hard to see
but I feel their
bulging POTENTIAL

THIRD DAY
It was a long night of
tense wakefulness spent
gazing at the starry sky,
listening to night sounds.
Bright crisp morning now.
My stomach has settled down.
Birds alight at the tops
of the trees. Rabbits move
out tentatively into the field.
Have they spent the night
listening for owls?

I feel like one of those rabbits.

Everything is so uncovered,
so raw. I question each move
I make, so tentative of my
footing. Thoreau would slap
a paddle against a tree
in the morning to wake up
the forest. I feel wrong for
crackling a leaf!

I want to run home.
I want to get away from this
unsettled feeling.
But I can't turn away.

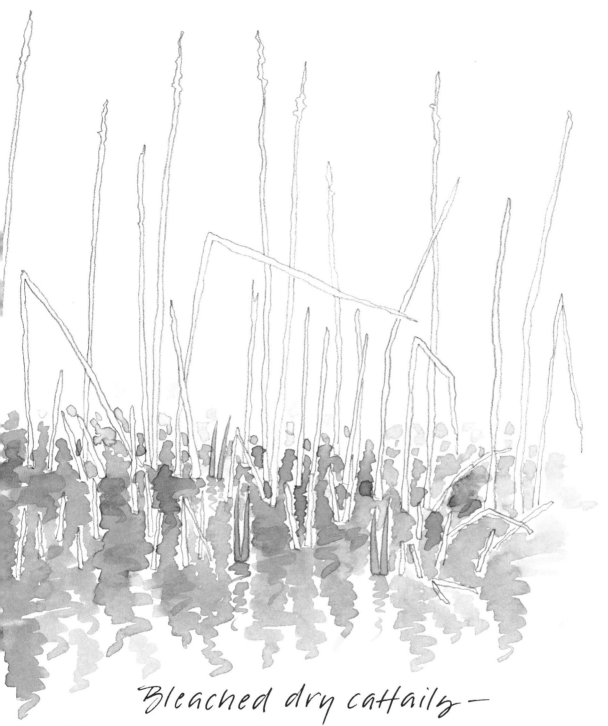

Bleached dry cattails—
those winter bones still standing—
new green blades appearing

FOURTH DAY

I wake before dawn, stomach cramping,
sheets soiled, body aching all over.
I stumble to the toilet and my insides
empty out. I manage to wash the sheets
in the sink before collapsing back into
bed, shaking with chills. Then the
woman staying in the other cabin
leaves a note on the door saying the
water supply is running low and to be
careful with usage. I sit down to
meditate and tears well up — I used
too much water trying to clean up.
In my panic I didn't think of others.
I'm sorry. I'm sorry. The little girl
cowering inside me is pulled in,
sick, scared.

I curl up in blankets and watch the
sky lighten, listen to birds calling out.
The soft clouds clear like an eyelid
opening. Nothing to do but hold myself
gently and study the sky. Everything
is so simple. I am broken-down,
unable to move, so I'm here in the
moment, frightened and quiet.
I pay close attention to myself
and the world.

I stay in the cabin all day, close to
the bathroom, sipping tea, looking
out the window. I am so weak.
My insides have turned to liquid.
I decide to wait twenty-four hours,
and if things haven't improved I'll
go home. But am I toughing it out?
No one is checking in on me. Perhaps
I need to be home with plenty of
hot water and extra sheets.

I can't trust my body anymore.
I'm afraid to fall asleep.

Afraid to give up and leave.
Afraid to stay and collapse further.

I should stay and be brave and
face these fears.
I should go, stop being so strong,
let myself fail.

I cry at how fallen apart I feel.

I decide to go out and find
some medicine.

I drive to town and walk into a drugstore. The pharmacist takes one look and sends me across the street to buy big bottles of Gatorade. Just making the effort to get to town calms my insides. Sipping fluids now and letting the cool creamy stomach medicine work its way down, my body feels more solid.

I had planned to call Steve from a pay phone, but I completely forgot. Even though this place is so lonely, I wanted to return to my quiet world. Beneath all my struggle to get away, to find comfort, the deeper part knows that this is it — this is the lonely place where the world opens.
This is where I want to be.

In the early evening I walk out slowly and sit at the top of the wide meadow. The sun is sinking down, shadows stretching out, the day turning, closing, shifting to dark. I watch those woodchucks move around down the hill. Melodies of birdsong course through me. Little flies buzz around my face. I let them buzz.
Quiet body. Solid ground.

S P R I N G W O O D S

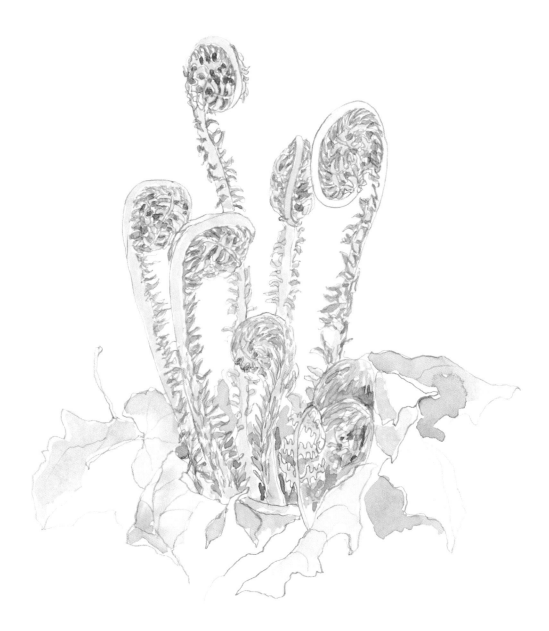

Bowed heads gathered —
an unfurling of ferny

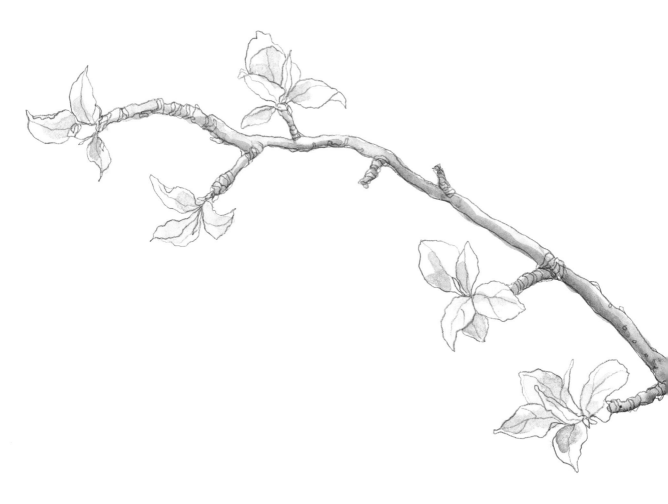

Each time, the beginning of retreat
 has this quality of searching, pushing,
 needing to achieve something
 and being disappointed,
 not getting it right,
 failing at the task.
 Then everything falls apart
 and I break down and collapse.
 When I open my eyes again
 the world is just there, waiting,
 everywhere.

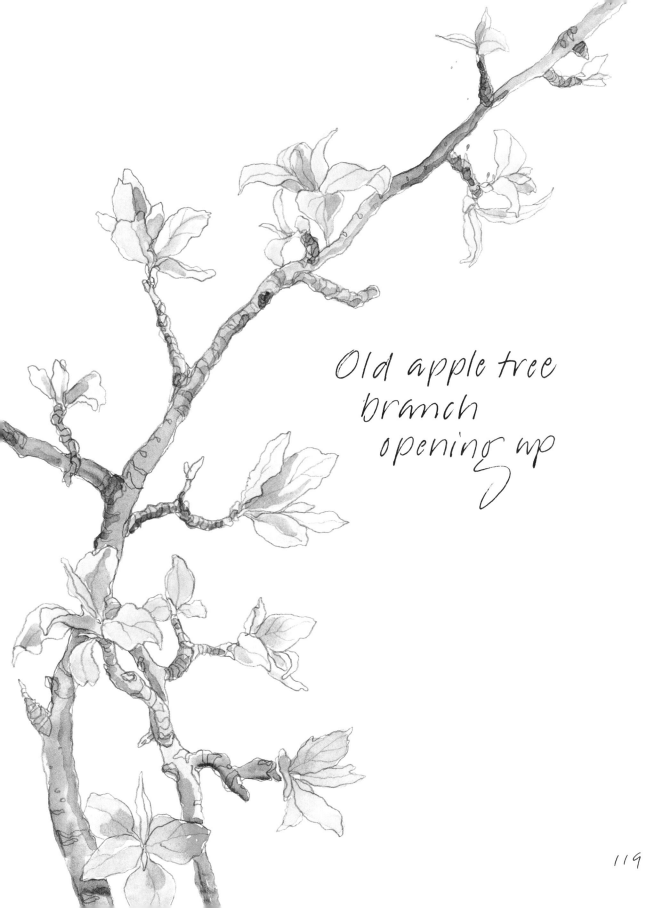

Old apple tree
branch
opening up

119

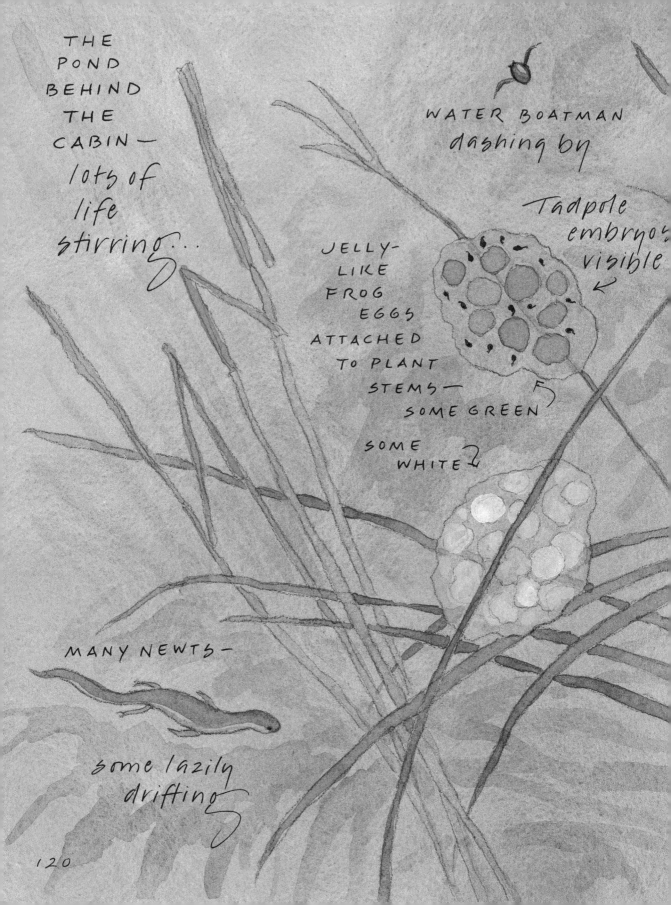

THE POND BEHIND THE CABIN— *lots of life stirring...*

WATER BOATMAN *dashing by*

JELLY-LIKE FROG EGGS ATTACHED TO PLANT STEMS— SOME GREEN

SOME WHITE

Tadpole embryos visible

MANY NEWTS—

some lazily drifting

120

pausing—
floating

PORTABLE
CASES
CONSTRUCTED
AROUND
CADDISWORMS

diving
down—
propelled
by
tail

They move
slowly along the
water grasses

BOTTOM
VIEW
OF
WORM'S
HOUSE

Plant
twigs laid
in spiral pattern

121

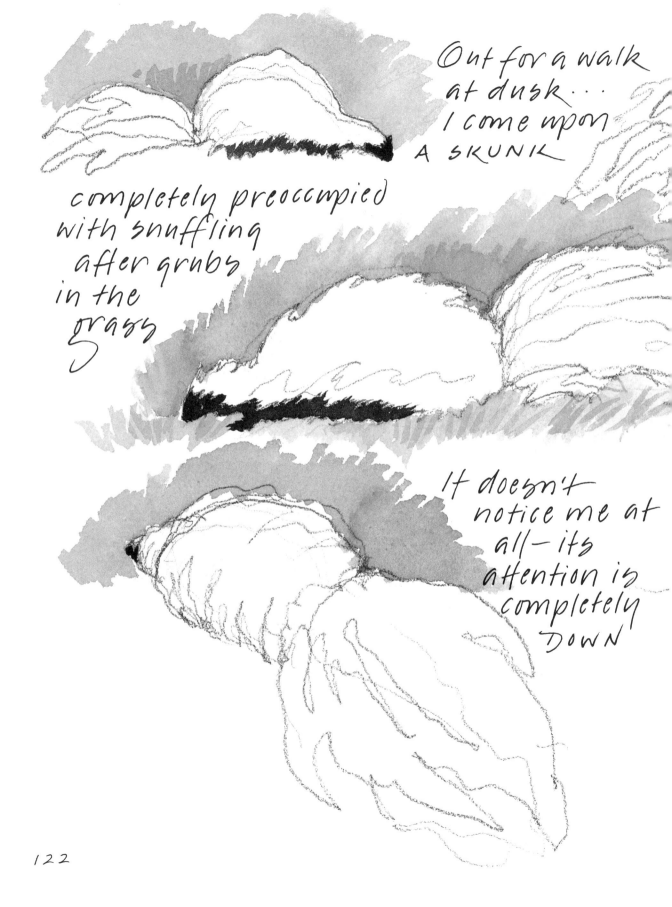

Out for a walk
at dusk...
I come upon
A SKUNK

completely preoccupied
with snuffling
after grubs
in the
grass

It doesn't
notice me at
all — its
attention is
completely
DOWN

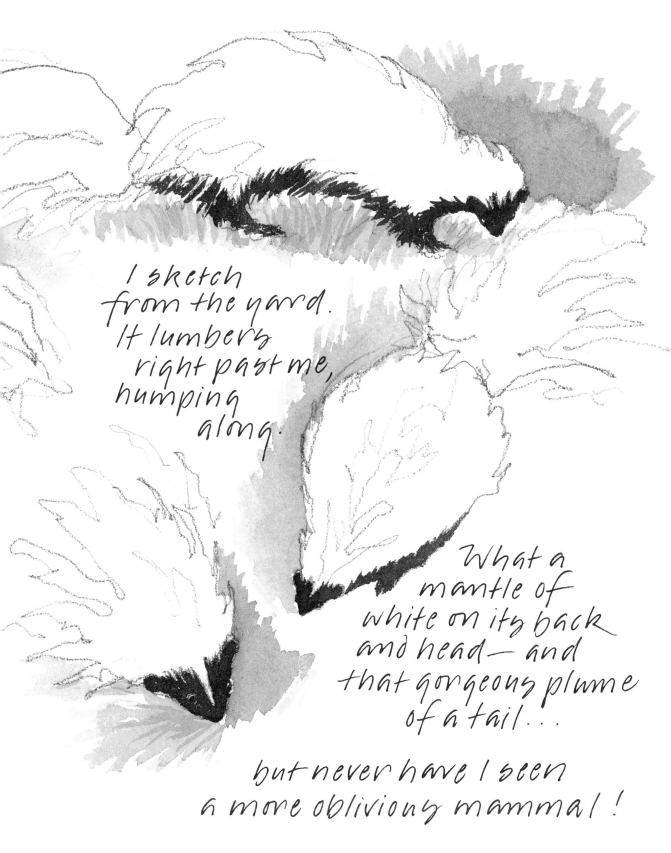

I sketch
from the yard.
It lumbers
right past me,
humping
along.

What a
mantle of
white on its back
and head— and
that gorgeous plume
of a tail...

but never have I seen
a more oblivious mammal!

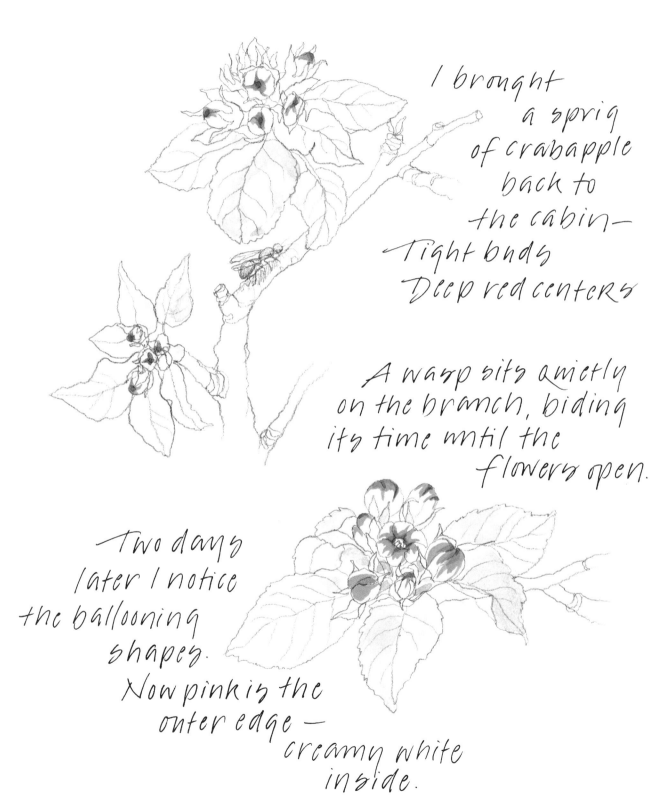

I brought
a sprig
of crabapple
back to
the cabin—
Tight buds
Deep red centers

A wasp sits quietly
on the branch, biding
its time until the
flowers open.

Two days
later I notice
the ballooning
shapes.
Now pink is the
outer edge —
creamy white
inside.

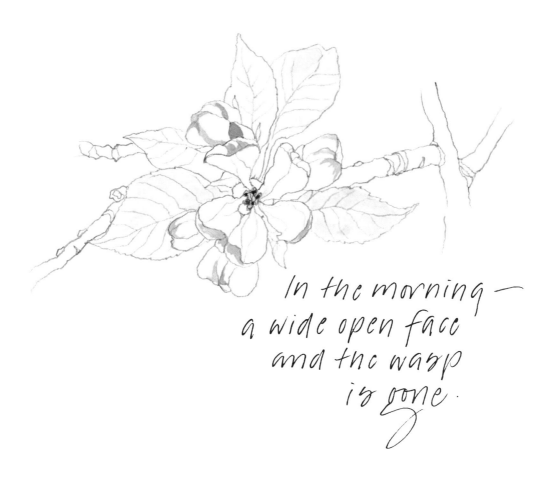

In the morning —
a wide open face
and the wasp
is gone.

FIFTH DAY
I napped a lot today. Each time I drifted off,
I thought to myself, I can sleep as long as I want.
No one needs anything from me.
I only have to take care of myself.

I've been thinking a lot about my mother.
When she was dying I sat next to her bed,
tracking her wandering mind, feeling
sadder and sadder. She seemed lost and
worried, walking into her own dark woods.
But then she turned to me, clear and
lucid, and said, "It's courage."
I nodded and leaned in closer.
"It's the courage to venture forth."
Her face was so light and open.
I smiled and said, "That's it!"
and we laughed softly together.

Trout Lily
growing in the
grass

I lie down to get
a closer look at their
bowed faces

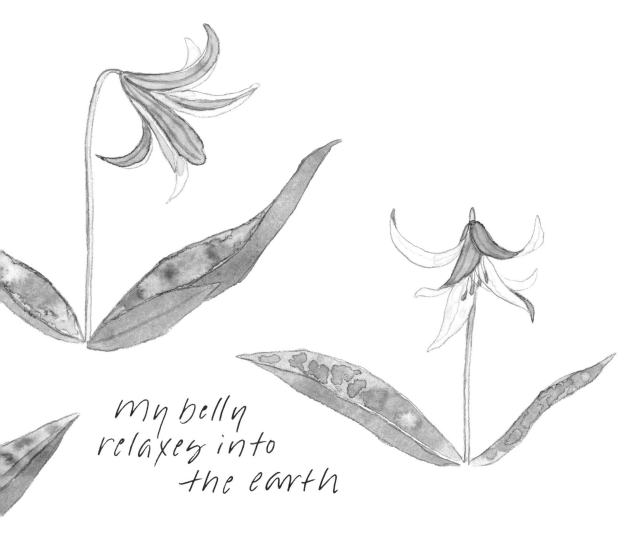

my belly relaxes into the earth

I have been afraid to go out in the woods at night on each of these retreats. At first I stayed inside when the sun set. Later I pushed against this fear, making myself walk out into the cold winter field in the dark. Now here I am again, sensing those dark woods, feeling my panic at the thought of entering their unknown world.

What is so frightening?
It is a silent place, a place of shadows, of not seeing, of not knowing.

I can't do it. I can't walk into that darkness. But there is something that draws me there. Somewhere inside I want to know it.

When I meditate I sit with the fears that arise in my mind. Can I sit in this outer darkness as well?

SIXTH DAY
I just want to sit in the sun
and stare at the moving leaves.
Will I be wrong if I never do another drawing?

the dark woods are waiting.
Will I be a coward if I never walk
into them at night?

Pema Chödrön says, "Go to places that scare you."
On the other hand she also says, "Relax as it is."

Have I failed in this retreat,
in this life,
if I don't end up happy?

Enormous pileated
woodpecker lands
in a nearby tree—

turns its head back
and forth as I stare
WIDE EYED

then vanishes
in a flash

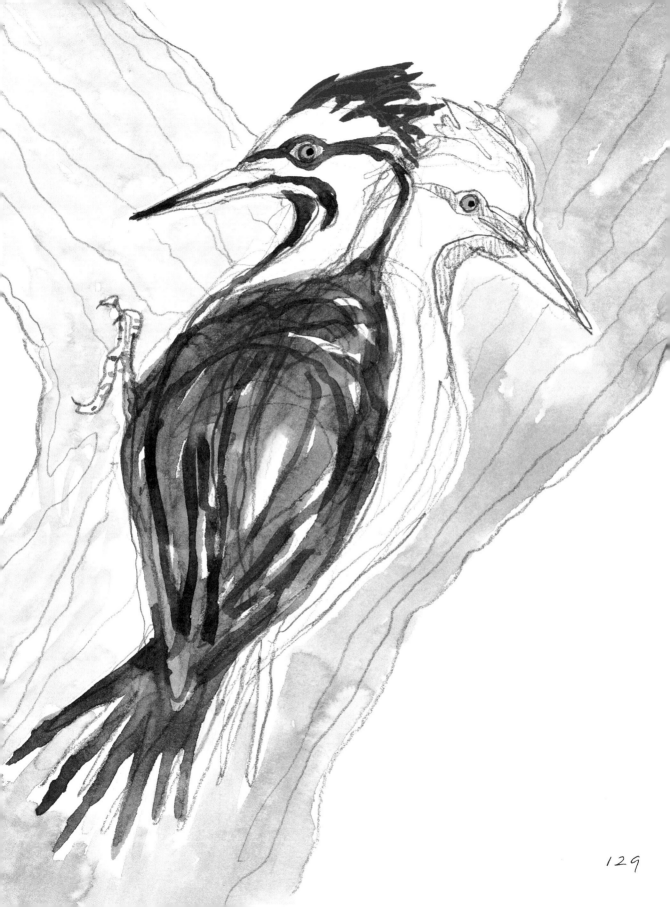

129

Thick cloud cover.
Can't shake this sadness.
Can I let it be here,
turn toward it –
gather it around me
like a dark shawl—
let it surround me?

Twilight. Transition.
The bridge between the
worlds. Twilight
surprises me.
I have stepped out
at dusk these last few
nights and had
unexpected encounters.
Creatures move about
in this shifting time.

It occurs to me that
the way to get into the
woods at night is to
enter at twilight and
let the darkness
gather around me.

I walk into the woods at dusk.

A hundred yards in I find
a broad rock and climb up
onto its flat surface. I sit,
looking down the gentle slope
through the slender trees.
Every so often I turn and
check behind me. No one
sneaking up. I lean back
and look up through the
treetops, catching the thin
crescent moon coming out
from behind the clouds
high above. A small bird,
on its way to its night roost,
lands for a moment nearby.
I can hear a faraway dog
barking. Then it's quiet again.
My heart is beating fast,
my breath high in my chest.
Afraid of the dark.
Afraid of what I can't see.
The leaves are rustling.
The woods are breathing.
A bird calls out softly.
Relax the brow.
Relax the mind.
Sitting, watching, listening.

131

The forest birds are quiet.
The trees seem to be giving
out the subtlest twitching
sounds — a leaf turning,
a branch relaxing,
the big body of the woods
settling. Then gradually
this flickering light
appears in the air.
Has it been here all along
and only now becomes
visible as the light fades?
It's everywhere, soft and
shimmering and lovely.
But I can't figure it out.
Is it inside my eyes?
Is it out in the air?
I get down off the rock
and peer around.
In a nearby clearing
the light glows stronger.
I start to walk toward it —
then suddenly it's all
frightening and I want
to be out of there,
out of the woods,
out in the open,
under that big clear
sky of stars.

I start to leave.
Then I stop, my heart
pounding. I turn around
and climb back up onto
the rock. The stars
are bright overhead,
clear and constant.
I gaze up at them
through the dark
branches, breathing
in the cool night air,
wide-eyed.
I think to myself,
"I have a right to be here."

I can't see the leaves
in front of me anymore.
Now the tree trunks and
the ground are the same
dark tone, everything
merging together before
my eyes. The flickering
light is back. I let it be.

Then the darkness presses
in and a wave of nervousness
rises up again. I have to get
out of here. But I stay.
Remember to stay.
Is this what it's like to die?
Is it like darkness
surrounding, enveloping?
This is dark woods practice—
getting acquainted with the
fear, with the goodness,
with the heart.

133

My mother is dying
and I sit with her.
I see her confusion and
fear, grasping onto
fragments of knowledge
but never following
through to a deeper
wisdom. She could not
guide me. This painful
truth makes me cry
and mom, sensing
emotion, turns, worried.
I reassure her that I'm
okay. My tears have
opened some deep door
inside and I breathe out,
relaxing into this moment,
a bigger truth.
Her uncertainty and
confusion are my own,
also her willingness to be
brave and simple and true.
By her vulnerability she has
shown me the way through.

I sit in the dark woods now
and feel the flickering
movement of life everywhere.

It's pitch black when
I finally get up.
I feel my way off the rock
to the ground. and
through the blackness.
Keeping a hand in front
of my face to hold back
the branches, I move
slowly down the slope,
my night eyes picking
out the tree trunks ahead,
my feet feeling for rocks
and logs on the forest
floor, all my senses open.
Here I am, a large
creature moving through
the dark forest.
Is anyone watching me?
Just as I step out of the
woods, a bat banks and
turns right in front of my
face; its soft wings beat
the air against my cheek.
It feels like a salute.

LAST DAY
I wake at 5:30 AM to
birds singing in the rain.
The rain is steady now,
everything outside
is soft and moist.

After breakfast
I sit looking out the window
drinking tea. I see myself
surrounded by great voices of worry
poised like armies on the hillsides all
around. Their banners are flying,
horses rearing. They're getting
ready to gallop down and
surround me and scream
in my ear, "Get going! Don't
you realize how much you
have to do when
you get back home?"
But the boundary
of retreat is strong as
a fortress. I hold them
off with a firm move of
my hand. There is
no place to enter.

I will sit this morning,
following the breath,
watching the movement of
mind, watching the movement
of shadows out the window.
Then I'll pack up
and head home.

The rain has stopped.
Sunlight is coming
through the mist.
A drop of water works its way
along the
windowpane

A L L

T H E

W A Y

D O W N

The truth is
 that each time
 I think I'll be scrambling
 to get out of here.

And each time
 I slowly,
 longingly,
 turn away.

Acknowledgments

Many people nourished the making of this book with their love and encouragement. Some I would like to thank especially are:

my father, Philip Bash, for his delight and
 interest in life
my agent, Joe Spieler, for asking for more
 than I thought I was capable of
my editor, Emily Bower, for knowing how to
 draw out my true nature
Don Grumbine, for being a genuine guide
 on the inner path
Steve Clorfeine, for his early crucial
 encouragement
Patricia Anderson, for her steady support,
 clear counsel, and powerful friendship
my writer's group– Carl Frankel, Hudson
 Talbott, Mitchell Ditkoff, as well as
 Patricia Anderson—for being the
 catalyst that rekindled this book to
 completion
Davis Te Selle and Stephanie Kaza, for their
 kind eyes and deep hearts
Hannah Hinchman, for encouraging me to
 handwrite the whole thing
Eloise Morley, for her close listening and
 understanding
Laura Marshall, for her nourishing spirit

Christian McEwen, for walking the path
 of slowness with me
Clark and Yemana Sanders, for providing
 the rich space for these retreats
Parker Huber (and the Glenbrook and Crestone
 communities) who gently received the
 first readings of this material
my son, Wiley, for letting me leave and welcoming
 me back over and over
my husband, Steve, for seeing what I needed,
 giving me the idea, believing in my
 process, and supporting me with
 enormous love all the way through
my Buddhist teacher, Chögyam Trungpa Rinpoche,
 who called me out of hiding
 and showed me how to live

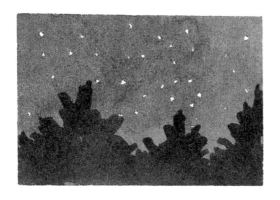

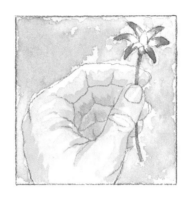

About the Author

Barbara Bash has written and illustrated a number of books on wildlife and natural history including DESERT GIANT: THE WORLD OF THE SAGUARO CACTUS and SHADOWS OF NIGHT: THE HIDDEN WORLD OF A LITTLE BROWN BAT. Her books have been featured on READING RAINBOW and listed on the John Burrough's List of Nature Books for Young Readers, the Texas Bluebonnet Award Master List, and Outstanding Science Trade Books for Children. She teaches brush calligraphy, illustrated journaling and communication workshops in the U.S. and Europe. Barbara lives in New York's Hudson River Valley with her husband, Steve Gorn, and son, Wiley. Her website is www.barbarabash.com.

KTD Publications
Karma Triyana Dharmachakra
335 Meads Mountain Road
Woodstock, New York 12498
www.ktdpublications.org

Second Edition, printed in Singapore
ISBN 978-1-934608-31-9
This edition is printed on acid-free paper that meets
the American National Standards Institute 239.48 standard.

First Edition, printed in Singapore
Library of Congress Cataloging-in-Publication
Bash, Barbara
True nature: an illustrated journal of four seasons
in solitude/Barbara Bash – 1st ed.
ISBN 1-59030-164-1 (pbk: alk. paper)
1. Natural history – New York – Catskill Mountains.
2. Seasons – New York – Catskill Mountains.
3. Nature – Religious aspects – Buddhism. I. Title
QH105. N7B375 2004
508.747'38-dc22
2004007813

The artwork for TRUE NATURE
was created from the sketchbooks I filled
during my retreats. Some of the images were
scanned directly into this book. Others I redrew in
the same spirit to fit the design of these pages. The art
was created with pencils and watercolors, using Arches and
strathmore papers. The text was all handwritten using
various sizes of Micron fine-line pens. The larger
captions were written out with pointed brushes.

A sketchbook allows one to explore many
styles of drawing. Each subject calls forth a
different visual response, sometimes precise and
detailed, sometimes loose and immediate.
For the most part I chose the relaxed line,
the simpler, less polished approach, since
this is the true nature of sketching.

I hope that TRUE NATURE will inspire
you to pick up your own sketchbook,
step outside, and discover
what is waiting for you—
ready to be drawn
and seen.

A Way to Begin...

Opening the sketchbook and getting
the pencil moving on the page
can be a surprising challenge.
The aliveness of drawing and
writing is often surrounded
by a powerful veil of fear
and hesitation.

Here are some ways I have discovered
to step through this veil, this fog
of whispering, doubting voices,
and get onto the page of one's life
again and again.

The exercises that follow focus on
how to SEE — what we CHOOSE to draw —
and what this REVEALS
about ourselves.

The Alive Line

Begin by drawing something that is always available to you - your non-dominant hand.

This is an exercise in blind contour drawing that trains us to slow down and look closely.

Hold your hand up and turn your body away from the page. Touch the pencil to the paper. Look at your hand.

Imagine a tiny imaginary insect is slowly exploring the surface. Your eye follows its movements along the edges, over the tiny hills, into the wrinkles and crevices.
Your pencil moves on the paper, tracking the path of the insect.
Your drawing hand slides on the page as the pencil moves.

Don't look back at the page. This is hard to do! It is impossible to be accurate without checking back, yet something alive and true can come through when the judging mind has nothing to compare.

Stay with this "blindness" as long as you can, then look back and admire the quirky breathing lines you've made.

147

Blind Contour again

Pick a different hand pose
and work on a new sheet of paper.
This time you can check back to the page
at some point to get your bearings,
then head off again, following that imaginary
exploring bug. Keep your drawing hand sliding
as the pencil moves. Let your fingers relax —
and your belly — and your breath.

Getting familiar with this feeling of being lost,
of not knowing where you are on the page,
leads us through a doorway into new perceptions.
This is the artist's world.

When you have stayed with this
second blind drawing as long as you can,
gaze on your lively lines.

Gradually we can learn to check back
to the page without tightening up.
Our drawings become more accurate AND alive,
with a fluidity moving between eye and hand.

Relaxed and attentive —
slowing down —
feeling our way along.

149

Adding Words—
a Poetic Voice

Placing words in relation to our drawings
can deepen and broaden the experience,
bringing what is within us out,
into the light and onto the page.

This time do three blind contour studies—
three different views—of a natural object.
Here I drew a dried leaf.
Now write three words or short phrases
near the drawings.

The first phrase describes what it is,
a simple observation—
THE CURLED LEAF.
Place this near the first drawing.

The second phrase describes
its quality and texture—
TAWNY, CRISP & STILL.
Write this near the second drawing.

The third phrase describes
the feeling of the object,
and perhaps yourself—
FLOWING DOWN, LETTING GO.

Let the words arise in sequence.
Listen closely.
Trust what shows up.

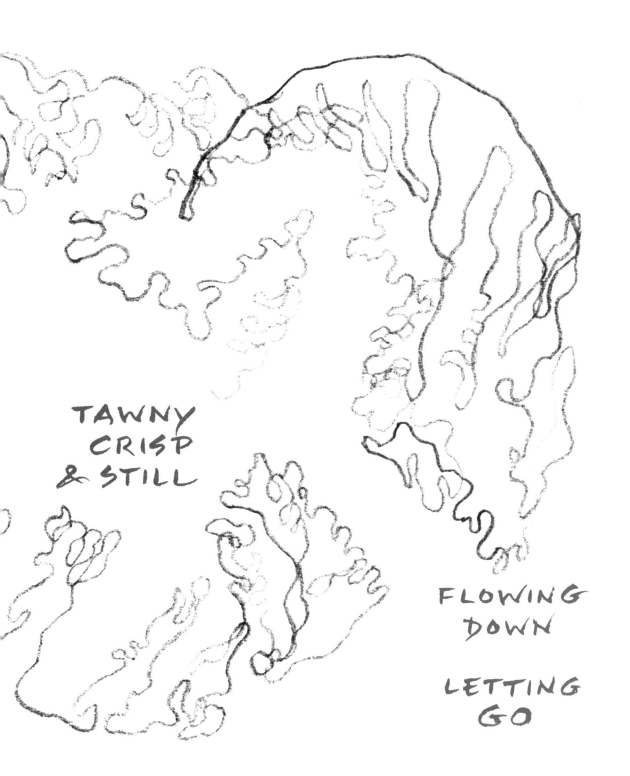

TAWNY
CRISP
& STILL

FLOWING
DOWN

LETTING
GO

One, Two, Three...

Now choose three natural objects that catch
your interest. Let them be things you can
hold in your hand that have different
sizes and qualities.

Use the contour practice in a loose way,
checking back to get your bearings every so often.
Be curious and wide-eyed.
Explore the shapes.
Take it easy.

Arrange the drawings on the page
as if they were in a conversation.
Draw the largest object first
and end with the smallest.

Again write a phrase or sentence
near each drawing. Position the words
so they balance and complete the image.

First line – the outer perspective – what it is.
DRIED GOLDENROD STALK.

Second line – the inner experience –
its nature and qualities.
LEATHERY VEINED LEAF SYMMETRY

Third line – the secret view –
what is close and true.
SHARP BRILLIANCE OF BERRY.

Dried
goldenrod
stalk

Leathery

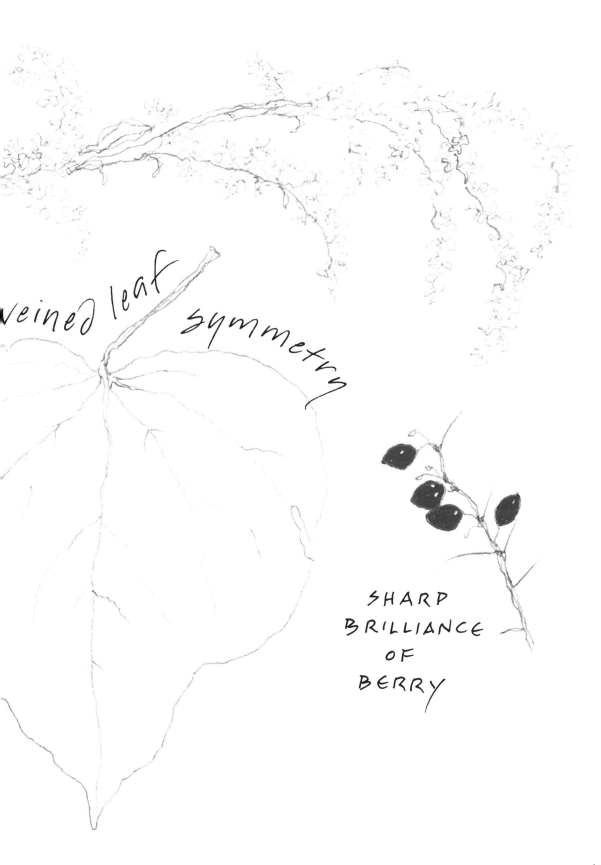

veined leaf symmetry

SHARP
BRILLIANCE
OF
BERRY

Adding Color

Pencil lines are the bones
of the sketchbook.
Adding color brings the page alive.
Here are some simple ways
of bringing color into your drawings.

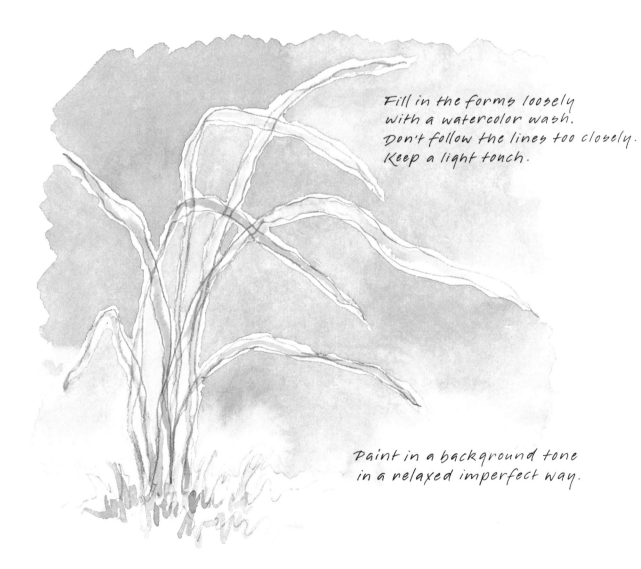

Fill in the forms loosely
with a watercolor wash.
Don't follow the lines too closely.
Keep a light touch.

Paint in a background tone
in a relaxed imperfect way.

Outline a blind contour
sketch with a colored brush line.

Let the form
breathe with a
little space
around it.

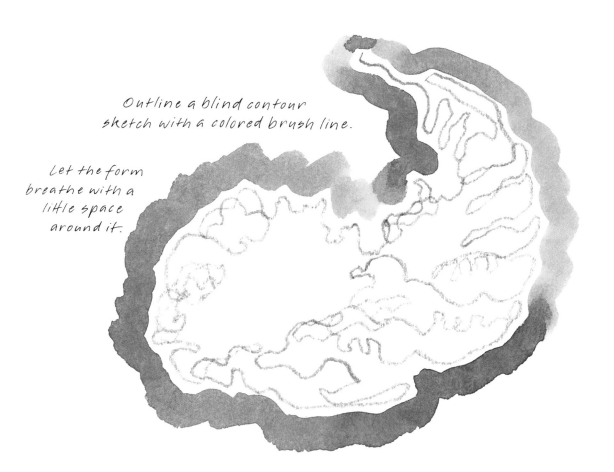

Write out the words
in changing colors
using brush or pencil or pen

following the contour
letting the letters
dance

Try this

Walk outside with your sketchbook—
into the woods, through a park or down
a city street. Let the first thing you draw
be something connected with the sky.
It could be a tree reaching up or clouds
drifting by. It is large and expansive.

Now choose another topic,
something resting on the earth.
Draw this second more horizontal form
in visual contrast to the first.
They can touch and overlap on the page.

Pause until you find a third object,
something small that catches your attention.
Place this detail so it balances
and completes the page.

Now write a sentence or phrase near each image.
Let the words arise slowly.
The first line describes the outer view—
the big picture.
The second line describes the inner nature—
the substance and texture of things.
The third line describes the heart—
the intimate voice.
You may be describing the small object,
yet it could be about you in the end!

This three step drawing and writing process
is done on the spot—immediate and fresh.
"First thought, best thought" Chögyam Trungpa liked to say.
It is a contemplative practice that slows us down,
opens our eyes, and reveals, at this particular moment,
our true nature.

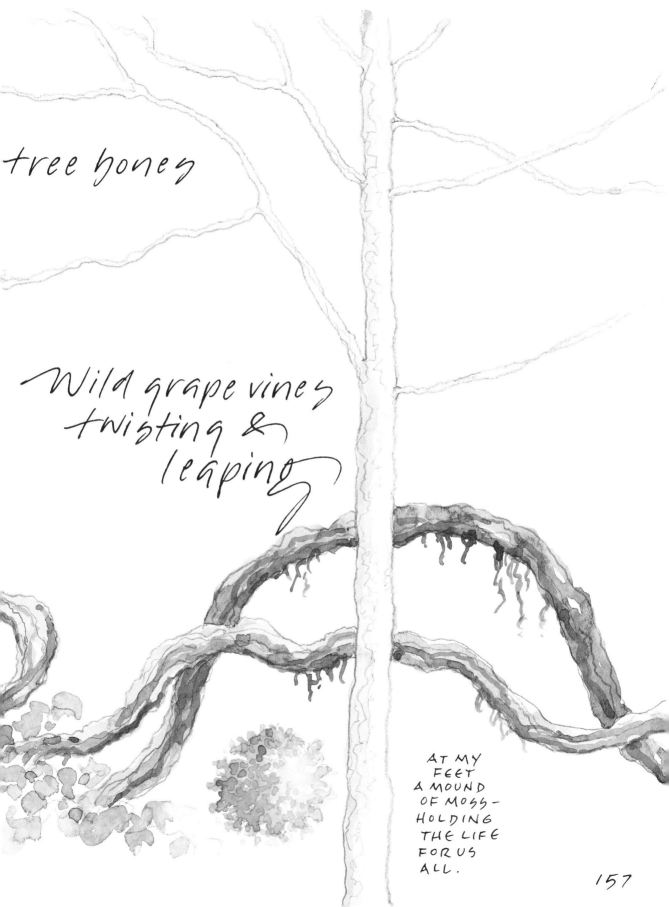

tree honey

Wild grape vines
twisting &
leaping

AT MY
FEET
A MOUND
OF MOSS —
HOLDING
THE LIFE
FOR US
ALL.

157

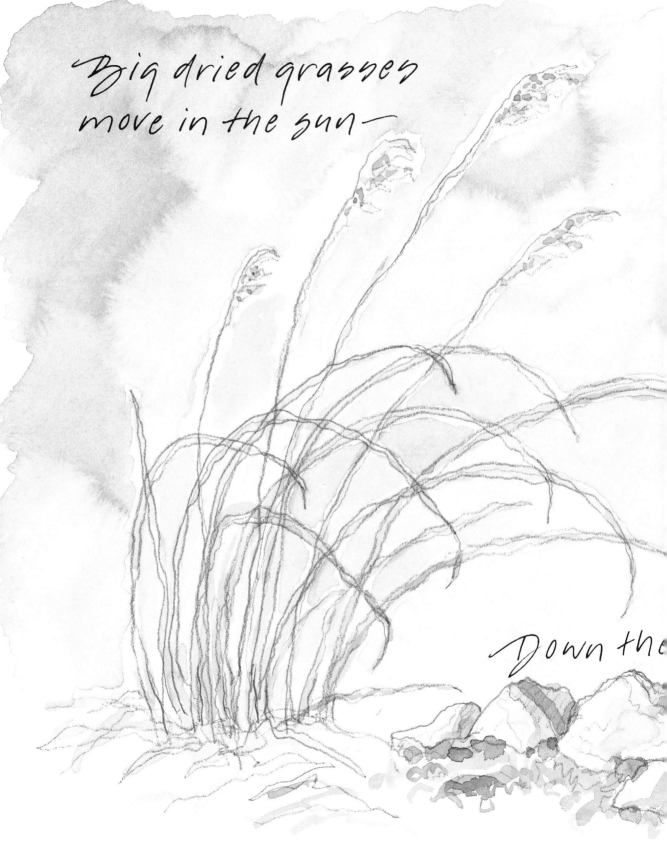

Big dried grasses
move in the sun—

Down the

IN THE
GRASS
A SMALL NUT-
ENCLOSED
SECRET
UNKNOWN.

hill the still stones are piled loosely.

159

Drawing and writing
bring us into the present moment.
We settle in where we are.
Tight lines relax.
Perfection drops away.
Life shows up.

Yet finding the way into
the sketchbook can be challenging.
We forget where the doorway is
over and over.

While creating the journaling exercises
for this new edition – deep in the midst
of a Northeast winter – I weathered
those familiar attacks of doubt and despair.
I wish I could say it gets easier,
but it doesn't!

Stepping into the unknown
always takes fearlessness.
What we find on the other side
is our tender-hearted aliveness.

What else is worth doing
in the end?